DRAWING FURRIES

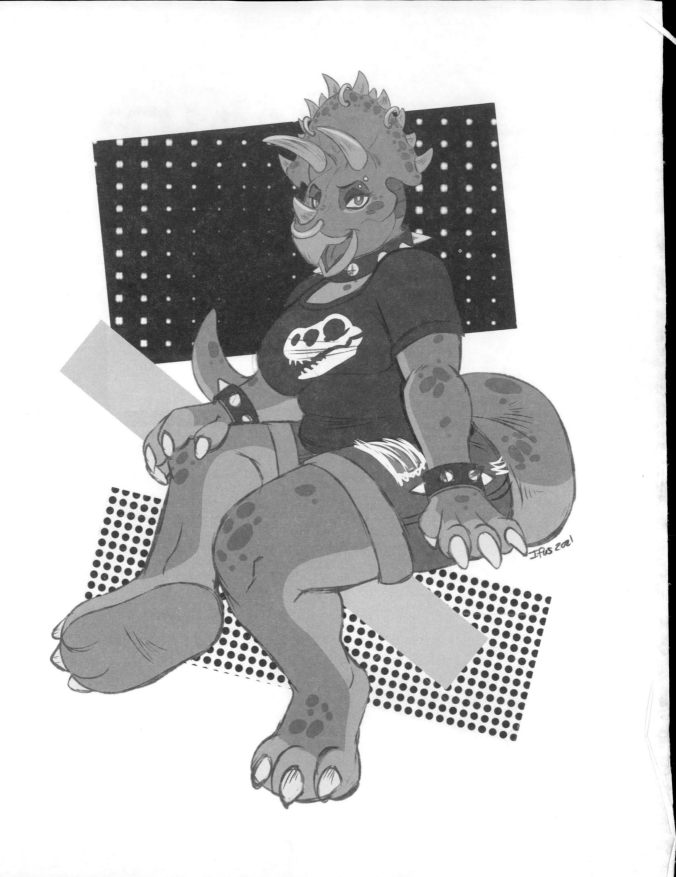

DRAWING FURRIES

Learn How to Draw Creative Characters,
Anthropomorphic Animals, Fantasy Fursonas, and More

STEPHANIE "IFUS" JOHNSON

ULYSSES PRESS

Published in the US by:
ULYSSES PRESS
PO Box 3440
Berkeley, CA 94703
www.ulyssespress.com

ISBN: 978-1-64604-161-9
Library of Congress Control Number: 2020946967

Printed in the United States by Bang Printing
10 9 8 7 6 5 4 3 2 1

Acquisitions editor: Casie Vogel
Managing editor: Claire Chun
Project editor: Renee Rutledge
Editor: Kate St.Clair
Front cover design: Flor Figueroa
Interior design and production: Jake Flaherty
Photographs: shutterstock.com

Dedicated to my dear husband Xander, family, and friends. Thank you for encouraging me throughout my life, and for your love and support!

Contents

Section 1
Understanding Basic Facial and Body Features . . . 5

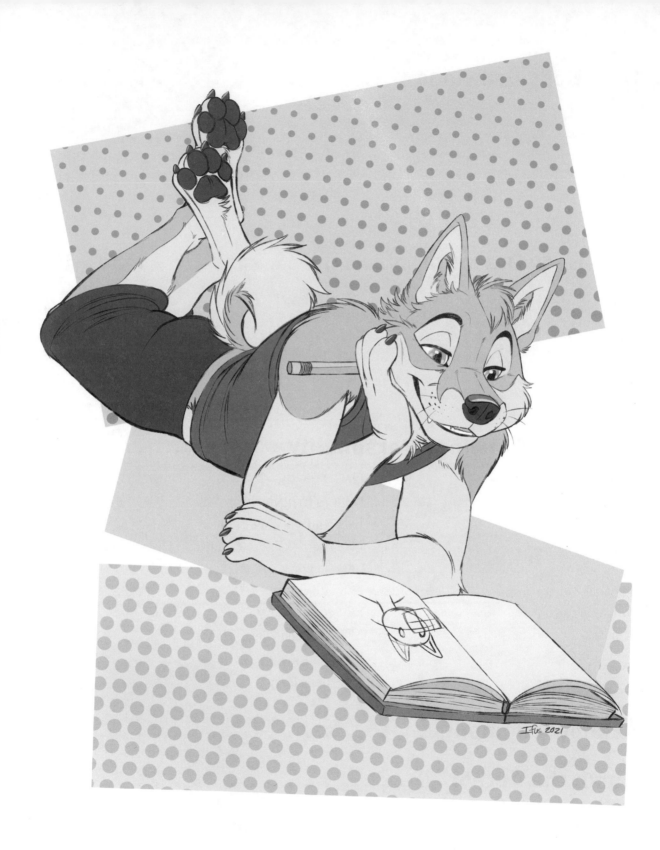

Introduction

Hello!

I hope this art book can provide some inspiration and tools to help you gain experience and confidence drawing animal characters. Whether you want to make drawing furries a big part of your life or get some practice drawing animal characters—this book is meant to help everyone just starting out!

My way is not the only way to draw, but I will be showing you how *I* draw furry characters by looking at a reference and breaking things down into general shapes before adding details. I want to encourage those of you reading this to find your own voice and style as you learn to draw. You each have a unique voice that you can share with the art world. There is no right or wrong way to make art, and practice time will always aid in your improvement. I want you to have fun and create things!

The furry fandom is a welcoming place for anyone who is a fan of the anthropomorphic arts and characters in media. In the furry fandom, the arts are celebrated—conventions host art shows and auctions, artist allies, dealer's rooms, and panels/tutorials for those interested in learning and enhancing their skills. People of all ages are welcome to attend.

I wish you luck on your artistic journey and strongly advise practicing often! But I also caution you to take breaks and rest your hands.

—Stephanie "Ifus" Johnson

sample mood board

GETTING READY TO DRAW

Before you start drawing, get your reference images out or make a mood board in an art program on your computer. Make sure to have multiple references. This will help you understand how to break things down into basic shapes—not only to make your drawing structured but also easier to read.

MOOD BOARD

Mood boards are just a collection of images that help you feel the mood or aesthetic of a piece. You can make a mood board for inspiration for a character, or set up a reference collage for yourself. They are really helpful during the artistic process, especially for big pieces or projects!

ART TOOLS

You can follow the instructions using any media you like or feel comfortable with. (You may even want to try media you aren't familiar with!) Digitally or traditionally, the steps work the same! Paper and pencil is a good place to start if you don't know or can't access the other media options yet.

Art supply recommendations are Strathmore papers and drawing pads, Faber-Castell pencils, Micron inking pens (these come in different colors!), and Copic markers.

There are other, more affordable markers by a few different companies like Prismacolor—and some great markers to experiment with are the Posca paint markers.

For digital artwork, I recommend the iPad for mobile drawing, and Wacom tablets. A nice budget monitor tablet is the XP-Pen Artist 22.

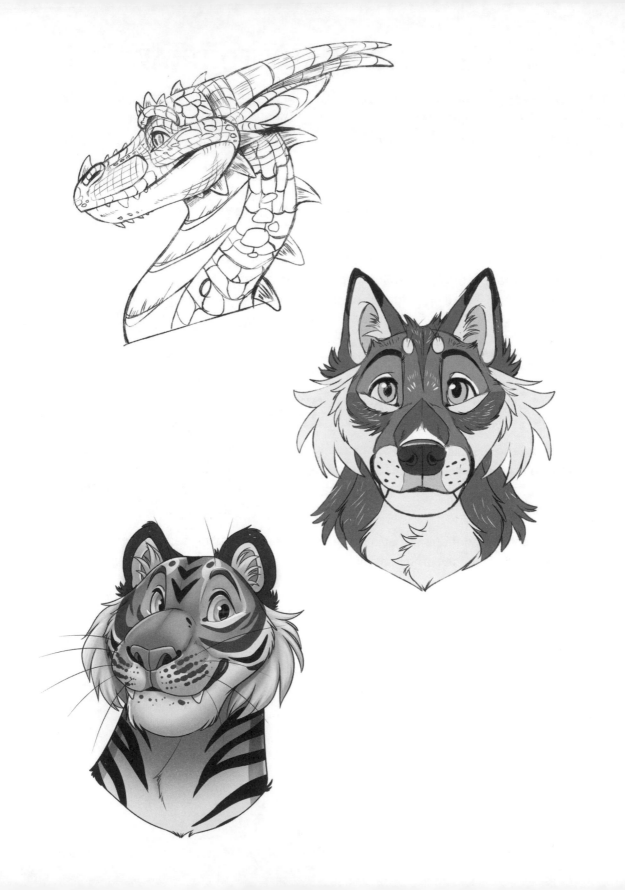

Understanding Basic Facial and Body Features

This first chapter will teach you how to draw furry heads and stylize from a reference. Follow the step-by-step instructions and practice, then you'll be ready for expressions and different views!

HEADS

Here, I will show you the steps to draw expressions and heads in ¾, side profile, and front-facing views. As you learn to use references and basic structure shapes, you will be able to draw your expressions and heads at any angle.

For a **¾ headshot**, the character is facing a side angle, but not completely. Both eyes are still visible, but the muzzle/nose will obstruct part of the face and make it appear smaller.

For a **side profile**, the character is completely facing the side, only one eye is visible, and only one side of the face should be showing.

Front-facing characters face the viewer. Both eyes, the sides of the nose, and the ears can be seen. The basic shape of the face is drawn symmetrically.

Wolf ¾ Headshot

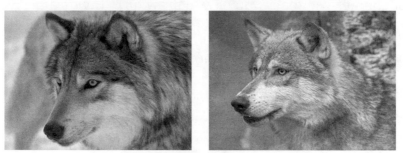

reference photos

Step 1 Lightly draw a circle. Within the circle, draw a line vertically and horizontally—they meet at the center of the face, dividing it into four quarters. You'll want to draw your structure with lighter, sketchier lines and do your details with heavier, refined linework.

Step 2 Look at your reference images of the wolf. Keep in mind the slope of the muzzle and proportions to the face. You can exaggerate these shapes the more experienced you get—when you find your style! Draw a box or cylinder for the muzzle. To make sure your perspective is correct, draw a line down the middle of the muzzle showing the center.

Draw two circles for the placement of the eyes. Draw a line across the front and side of your muzzle about 2/3 of the way down. The top of the muzzle is larger than the bottom on a wolf.

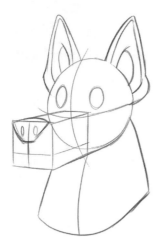

Step 3 Draw the ears on, keeping in mind the ear shape on your reference, and the proportion to the head. Draw out the neck. You can make it thicker and more animal-like or more slender to make it more on the humanoid side; it's up to you! Draw in the nose, and draw two circles as guidelines for the nostrils.

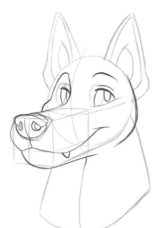

Step 4 Add the eyes and nose details, and draw in the shape of the mouth. Include the eyebrows (if you want) and eyelid lines.

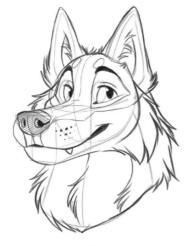

Step 5 Add details and fur! Notice which direction the fur goes on your references to determine how to draw the ends of the hair. Take note of whisker dots, whiskers, if there are teeth sticking out, or any other details you'd like on your character. You can customize it however you want (see Section 4 on page 125 for more on how to detail a new furry character). Add your personal touches and stylizations too!

Wolf Headshot Side Profile

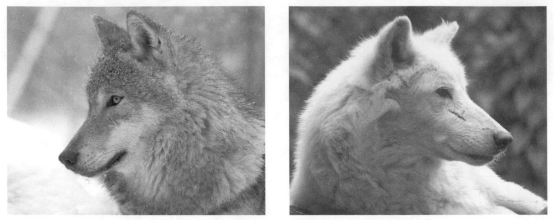

reference photos

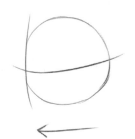

Step 1 Draw a circle again. Draw the horizontal line the same, but this time draw the vertical line to the left (or the right, whichever you are more comfortable with).

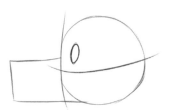

Step 2 Looking at your reference of a wolf profile and using your observation skills, draw a box similar in proportion onto your circle. Now draw one circle on for eye placement. You will only be seeing one eye from this viewpoint.

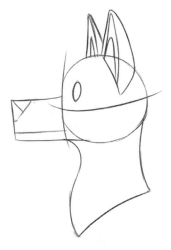

Step 3 Draw on the ears. You should see one from the side facing you and a bit over the head, depending on the pose. Next make a line to place where you will be drawing the back of the nose. Then you can finish this step by drawing on the neck guideline. It's nice to have the heads drawn and cropped at the neck for things like headshot sketches and badges! Draw on a mouth line going toward the circle from about ¾ down on the muzzle; this is your mouth guideline.

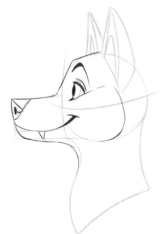

Step 4 Start to detail your face. Draw on your eyes, eyebrows, and nose. Using the reference, see how you can stylize and break things down into shapes. Refine the muzzle and head shape, and then you are ready for the last step!

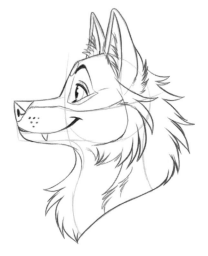

Step 5 Add the final details like fur, muzzle spots, and markings—and your wolf side profile headshot is complete!

Wolf Headshot Front View

This is the trickiest view, since getting symmetry perfect is pretty tough. You can do it with practice and determination! If you are drawing digitally, you can use a symmetry tool in some drawing programs, or draw half of the face and copy it, then flip it over. If you're using traditional drawing media like a pencil and paper, you can use a mirror to reflect your artwork. This will show you where you need to adjust your lines, similar to flipping things to check them digitally!

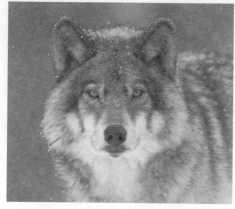

reference photo

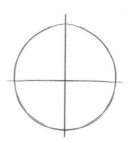

Step 1 Draw a circle like before, but this time put the lines dividing the face in the middle—one dividing the circle horizontally, one vertically.

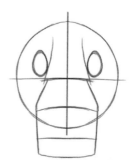

Step 2 Draw the box muzzle, but have your rectangle coming from the front toward the viewer. Looking at your reference, notice the muzzle comes down a bit, so draw a line back where the muzzle meets the face, and a line toward the viewer where the nose would be. Draw a line ⅔ of the way down in the front, like in previous drawings.

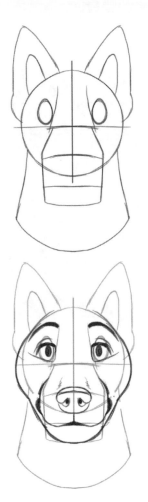

Step 3 Draw two triangular shapes for the ears. They will rest on top of the circle above the eyes. Add your neck in—the sides come down from under the cheeks on each side.

Step 4 Start to detail your eyes, nose, and mouth. You should see both nostrils and both eyes in this view. Add eyebrows in if your design calls for it!

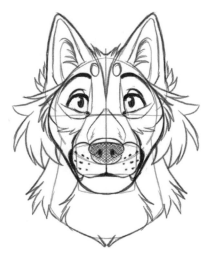

Step 5 Add in your final details like fur, whisker dots, and markings. Feel free to take your eraser and clean up some of your lines.

Tiger ¾ Headshot

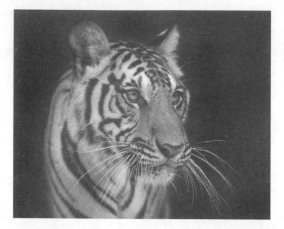

reference photos

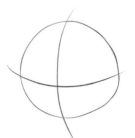

Step 1 Start by lightly drawing a circle, and then draw your vertical and horizontal lines in a ¾-view direction. You mostly see one side of the face, and the other side is turned away a bit.

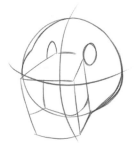

Step 2 Draw a box in perspective on the front of your circle. Tiger muzzles start between the eyes; but unlike a wolf, it's much thicker and shorter. Draw your circles for eye placement guides, and add a line halfway down the front in the middle. This is the top lip/part of the middle of the nose. Draw two lines coming from the center going up in a U shape.

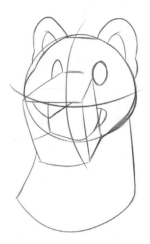

Step 3 Add in a triangle for the nose in the front, and draw on round half-circle shapes on top for the ears. You can start to detail things a bit more and add on your neck.

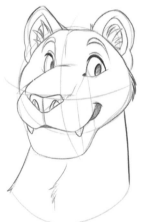

Step 4 Now you can start to detail your drawing to have eyes, eyebrows, a nose, and a mouth. You can start to detail the ears here and add some fur inside.

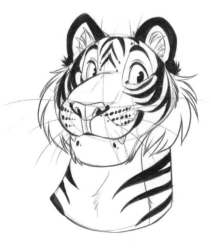

Step 5 Final details can now be added. Add in your stripes, whiskers, fur, and markings.

Tiger Headshot Side View

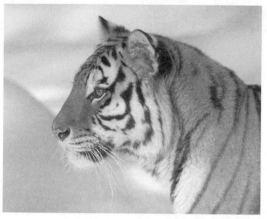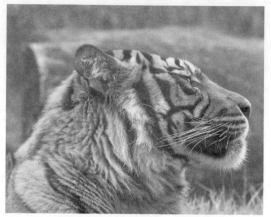

reference photos

Step 1 Lightly draw a circle, with the vertical line facing the way you want your tiger head to. People drawing with their right hands tend to find drawing characters facing the left easier, and same goes for the opposite. Your horizontal line should divide the circle in half going across.

Step 2 Draw a thick box shape for the muzzle—just like the ¾ head, but it'll be on the side of the circle. Add circle guidelines for eye placement; you will only see one eye from this angle. Then you can add a downward shape for a mouth guideline that tilts down from the front of the muzzle.

Step 3 Add half-circle shapes in for the ears. Depending on which way the tiger is moving their ears, you can either see one or one and part of the other at this angle, but less so than the ¾ view. Draw in your neck shape. Tigers have big, thick necks usually, but your tiger can have a more humanoid neck if you'd like. From the front of the muzzle, draw another line tilting up toward the top part of the muzzle. This will be a nose guideline.

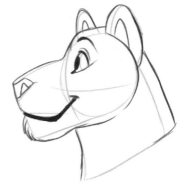

Step 4 Start to detail in your eyes, nose, and ears. Also draw in the cheek shape so you know where to put the fur. Draw in the mouth line, which is like a U shape going from the front to the cheek.

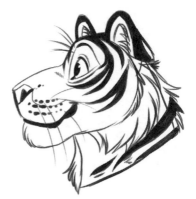

Step 5 Now it's time to add in the details to your tiger head and personalize it. Draw in your spots, stripes, and whiskers. You can use your eraser to clean up your lines a bit and erase some structure lines.

Tiger Headshot Front Profile

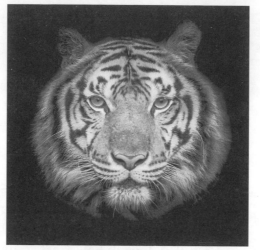

reference photo

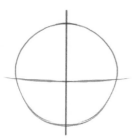

Step 1 Draw a circle and add a set of crosshairs in the middle, since your tiger will be facing forward.

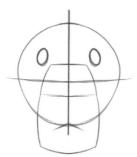

Step 2 Draw a front-facing box in perspective slightly angled down for the top of the muzzle. Draw two downward lines from the bottom of the circle down—these will be your mouth guidelines. Then add your eye guidelines by adding two circles symmetrically on each side of the bridge of the nose/muzzle at the top.

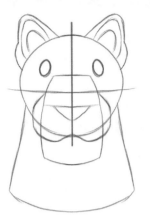

Step 3 Draw on two half circles along each side of the top of the muzzle—they should be wider than your bottom jaw. Finish the triangle shape for the nose, then add on the ears. Draw guidelines for the inner ear fur, and for the outside of the ear. Draw in your neck. The lines coming down should be coming from the back of the head. Your head will be a bit wider than the neck. Crop however you feel looks good!

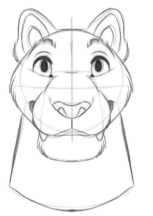

Step 4 Stylize and detail your nose, eyes, and mouth. You can have teeth poking out, and add lips. Draw on your eyebrows (if any!).

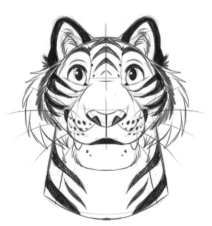

Step 5 Finish your drawing by blocking in some stripes, spots, and other markings. Add in the fur fluff on the cheeks, inner ear, and chin. Add in some whiskers and some eye shine (just don't color that part in or erase), and you're done!

Dragon ¾ Headshot

Dragons are a bit tougher to draw because we don't have photographic evidence—other than artistic and literary depictions. Dragons can be *anything* and can be based off of anything! So feel free to be creative with your designs. I'll be drawing a dragon I've made up for this how-to, but your dragon can look however you want using the same steps.

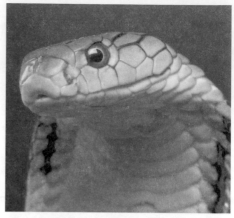

reference photo

Step 1 Start with a circle, and draw your crosshairs slightly to the side.

Step 2 Draw on your box in perspective for the muzzle. I'm drawing mine similar in length to a wolf, but yours can be whatever length you'd like. Draw in a couple of circles for eye placement. For this drawing, I'll reference reptile anatomy and draw my mouthline to the back behind the eye.

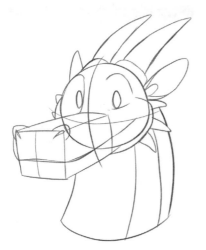

Step 3 Sketch on your dragon's features like nostrils, mouth shape, horns, and ears. Add in your neck shape, the back line coming from the back of the skull and the front coming from under the chin.

Step 4 Start to detail and stylize your dragon. Draw your eyes in and refine your face, spikes, and horns. You can also add plating to the neck.

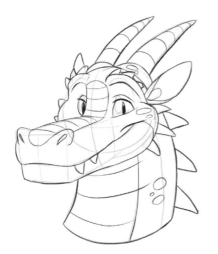

Step 5 Add in your last little details, like scales, spikes, and ridges.

Dragon Headshot Side Profile

Step 1 Draw a circle. Draw your crosshairs with the horizontal line going straight across and the vertical line going up and down, closer to one of the sides.

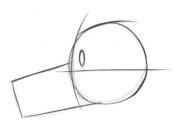

Step 2 Sketch in a circle for the eye. You will only be able to see one at this view. Draw in your rectangle for your muzzle, and a line connecting the slope of your muzzle to the top of the head.

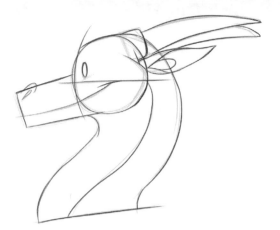

Step 3 Next add your features like nostrils, mouth, horns, and ears. Draw your neck lines from the back of the skull and from the bottom jaw down.

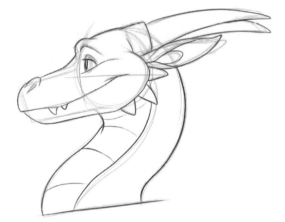

Step 4 Stylize and add in your eyes. Start to detail your features.

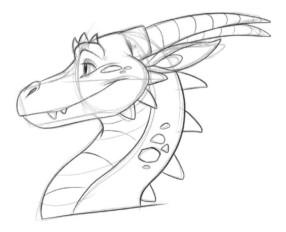

Step 5 Add in the final details, scales, spikes, and markings!

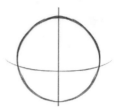

Step 1 Draw a circle with the crosshairs vertically and horizontally in the center.

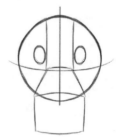

Step 2 Draw your muzzle coming toward the front, making sure to draw it in perspective so you can plan out the top, front, and bottom jaw. Add two circles symmetrically on each side of the bridge of the muzzle for eye guidelines.

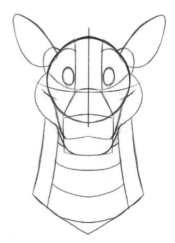

Step 3 Sketch in simplified shapes for your features, like ears and eyebrow ridges. Add in your neck from the back of the skull down. Sketch in your plating.

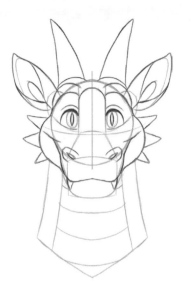

Step 4 Sketch in your eyes, detail your features, and add plating and spikes.

Step 5 Finalize your details! Add in scales, spikes, and plates to personalize your design.

EYES

Eyes are really important for character definition. They can define what species a character is, their emotions, and if they have or lack magical powers. Eyes can tell a story of the character's past.

I will be drawing eyes from reference and showing you how I break down and simplify the shapes.

Step 1 Draw a circle. This will be your eyeball.

Step 2 Draw the top and bottom lids—they wrap around the eyeball.

Step 3 Sketch the top lid thicker.

Step 4 Draw in a circle for the pupil. Add the tear duct, and draw in a line for the eyebrow. Note: reptiles do not have tear ducts by the eye like mammal characters do.

Step 5 Detail in your eyebrows and color in your pupil. Different species will have different shapes and colors to their irises and pupils.

Step 6 Add your own details and style!

ART TIP If you want to increase your skills at drawing eyes, practice drawing skulls! Drawing the eye sockets will help you understand how the eyeball fits in and can look from different angles. Observation while drawing different pictures of eyes helps too.

Feminine Eyes

When drawing feminine eyes, the top lid of the eye will have a much thicker line to it, and the eyelashes will be longer. Eyebrows can be drawn thinner, but this is not exclusive to feminine or masculine eyes.

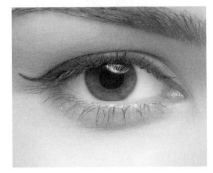

reference photo

Step 1

Step 2

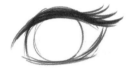

Step 3

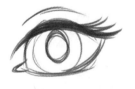

Step 4

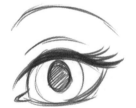

Step 5

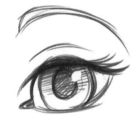

Step 6

Masculine Eyes

When drawing masculine eyes, the lines on the top lid are slightly thicker than the bottom, but not as much as the feminine eye. The eyelashes are much shorter. Eyebrows can be drawn much thicker, but this is not exclusive to masculine or feminine eyes.

reference photo

Step 1

Step 2

Step 3

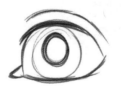

Step 4

Step 5

Step 6

Cat Eyes

Cat eyes are noticeable from their wide shape and large size. When exposed to a lot of light, cat pupils become vertical slits. In low light, they can grow large and round to focus on something to pounce on!

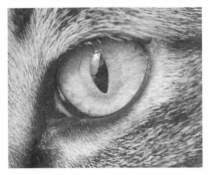

reference photo

Step 1

Step 2

Step 3

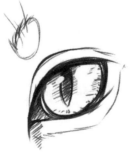

Step 4

Step 5

Fox Eyes

Fox eyes are very similar to cat eyes with their slit pupils, but they are much smaller on the head. They are drawn with a similar structure to canine eyes, with the difference of the slit pupil.

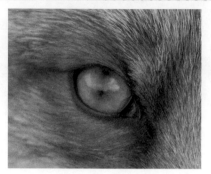

reference photo

Step 1

Step 2

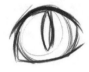

Step 3

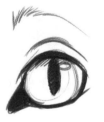

Step 4

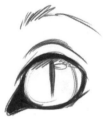

Step 5 You can make the pupil thinner too for a different look!

Reptile Eyes

Another eye with slit pupils is the reptile eye. This eye can also be used for drawing dragons and dinosaurs. Reptile eyes are completely round, have no tear ducts, and are surrounded by scales.

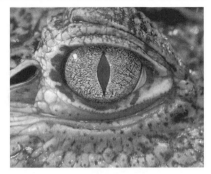

reference photo

Step 1

Step 2

Step 3

Step 4

Step 5

Wolf Eyes

Wolf eyes are intense and piercing, with completely round pupils. They have tear ducts and are similar to the fox eye in shape, except much larger.

reference photo

Step 1

Step 2

Step 3

Step 4

Step 5

Goat Eyes

Goat eyes are soft and oval. They have larger tear ducts, and the pupils are horizontal, rounded rectangles.

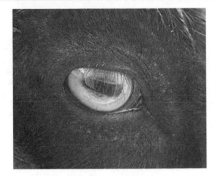

reference photo

Step 1

Step 2

Step 3

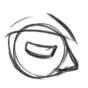

Step 4

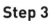

Step 5

EXPRESSIONS

Expressions are a great way to show how your character is feeling. You can also use these techniques on your full-body drawings to really sell your emotion with facial expression and body language.

I recommend getting a small mirror to keep at your desk where you can look at your own face while you are drawing. Professional artists and animators use this technique and make the faces they are drawing to really feel and capture the emotion. When you do this, feel which way your face is stretching.

Even though we are drawing furries, it's important to know how our faces work too. Because we anthropomorphize these animals, we want to stylize them to show human emotion. Animals do not emote the same way as humans, but we can take inspiration from their anatomy to show how they would if they could walk and talk like us.

Here are examples of animals making expressions that are human-like. You can reference them for your own artwork.

The dog's mouth looks like it is curved into a smile, and its eyes are closed. He looks really happy and content!

This cat looks scared or stunned! The ears are tipped back, the eyes wide, and the mouth partially open or pulled into a smaller shape.

This lion is angry! If you make an angry face in the mirror, you can see and feel the nose wrinkles on your face similar to the lion—your eyebrows are furrowed, your mouth is open, and your teeth are bared.

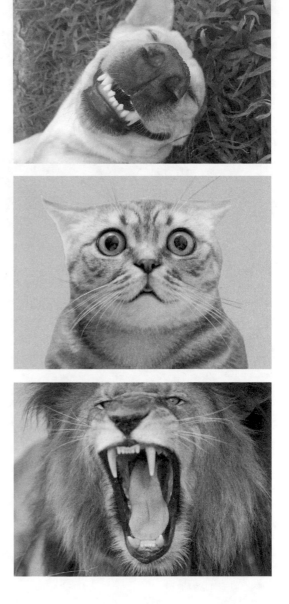

Observations like these and acting out your drawings can get you really connected to them and improve the result. It helps you understand the breakdown on how the body works, and helps you relate to the animals and characters you are drawing!

Happy

The best way to start is to look in your desk mirror and smile. Feel how your cheeks and forehead muscles move up. Look at how your face is and draw it out simplified like this:

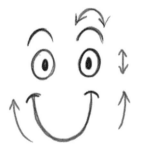

Your eyebrows are arched over your eyes, and the corners of your mouth go up in a smile. You can translate human-like emotions such as this into your stylized animal drawings!

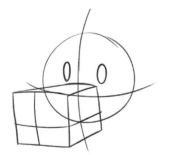

Step 1 Let's start with the previous headshot drawing steps to block out our head.

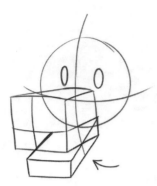

Step 2 Now let's draw a box opening up—this will be the bottom jaw. This wolf will have an open-mouth, happy expression.

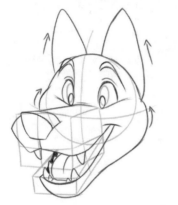

Step 3 Draw in your ears perked up, your eyes wide open, and your open mouth up in a smile.

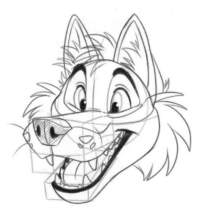

Step 4 Draw in your details and complete your character!

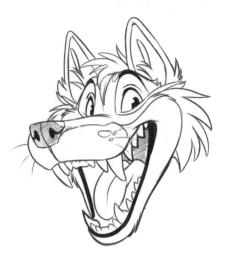

You can exaggerate your expression and make the mouth open really wide, so your character looks more excited!

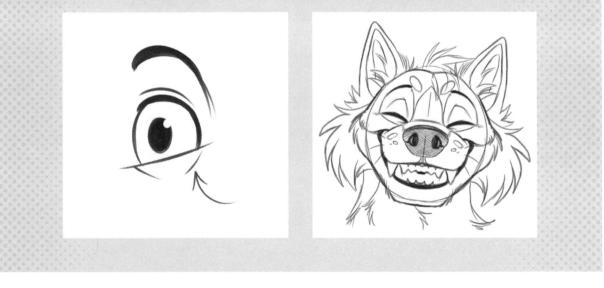

Extra Tips for a Happy Expression

When you have the bottom lid of your eye come up into the eye area, you can show the cheek muscles are pushing up for a more exaggerated smile.

Another way to show happy is to have the eyes closed, or the teeth in a grin!

Sad

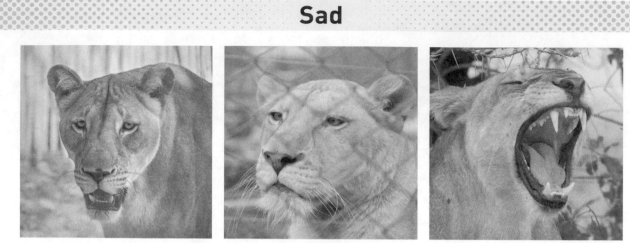

reference photos

Look into your desk mirror and make a sad face. Think of a sad song and look at how your face muscles pull down. Draw your emotion simplified like this:

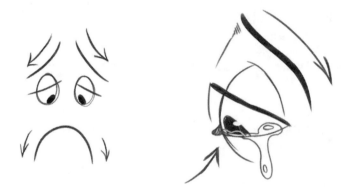

Your eyebrows are raised up toward the middle, but slope down to the outside. Your mouth is in a frown and the sides of your mouth point down. Your eyelids are partially closed as well.

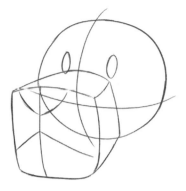

Step 1 Start with previous headshot drawing steps to block out your head.

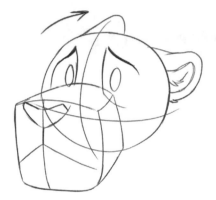

Step 2 Draw in what you learned from your emotion breakdown onto your character. Also add animal behavior—you can make the ears flatten to show the character is upset.

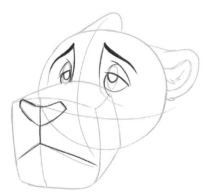

Step 3 Stylize your eyes. Add lines around the bottom lid to make your character look more tired.

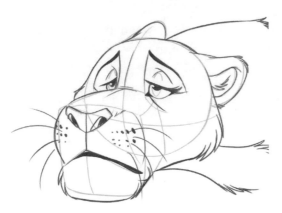

Step 4 Add in your details. You can push the expression by making the eyes more closed and tilted.

Extra Tips for a Sad Expression

You can add in some tears too, to show how sad your character is. The lower lid coming up, with eyes wet and full of tears, can show a really sad expression for something hurtful or touching.

Sad can include different variations as well; you can have a character quietly cry and shed some tears. Or you can have them crying and wailing with their mouth open and eyes closed to express how upset they are.

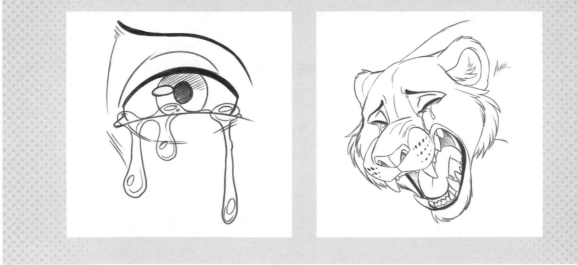

Angry

The dragon reference is a compilation of both existing creatures and fantasy elements. This one will use more of your imagination! You can gather your own references and make a mood board—or use a preexisting dragon character that you have.

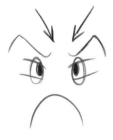

Look into your mirror and make an angry face by thinking of something that made you mad. How does your face feel? Your eyebrows go down on the inside and up on the outside; your mouth is in a frown similar to when you are sad, or your teeth are bared.

Let's break down this expression.

Step 1 Follow previous steps from the headshot drawing exercises to build your head.

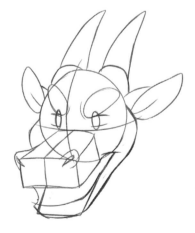

Step 2 Draw in your basic shapes and angry expression. Make the eyebrows go down on the inside and up on the outside. Draw the ears flattened or going back. You can draw the mouth open if your teeth are bared or the character is snarling!

Step 3 Stylize and draw in your features, teeth, eyes, and other lines—like between the eyes and by the mouth—to push the expression.

Step 4 Push it even further! Draw your lips curled, showing the gums and more of the teeth. Draw the pupils very narrow, and add some smoke coming from the dragon's mouth for a furious expression.

Extra Tips for an Angry Expression

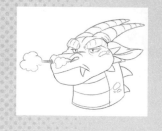

Anger has a range as well and can mix with other emotions. You can have a character be annoyed or grumpy.

Your character could also be livid and go on a rampage!

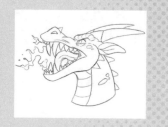

Scared

Look in your mirror and make your best scared expression. Your eyes are widened, your mouth is open, your eyebrows are raised. You are alert and surprised!

Let's draw a breakdown of this emotion.

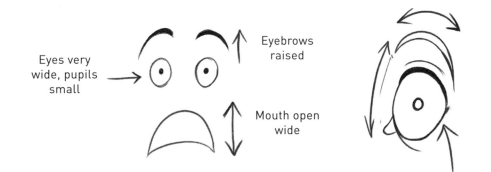

Eyes very wide, pupils small

Eyebrows raised

Mouth open wide

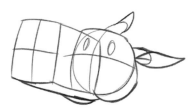

Step 1 Use previous headshot drawing techniques to structure your head. Draw the ears flattened, and head tilted back.

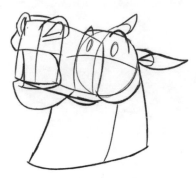

Step 2 Draw on your flared nostrils and surprised eyebrows; your horse's mouth will be wide open. Horse mouths do not stretch back like dog and reptile mouths do.

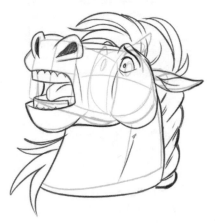

Step 3 Draw and stylize your horse. Add teeth, and add eyes showing small pupils for shock. Draw in a mane and color in your nostrils.

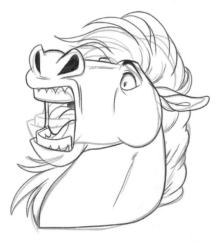

Step 4 You can exaggerate your expression further! Curl the lips up in the corners, showing more of the teeth. Nostrils are flared even bigger, and eyebrows are super high up.

BODIES

Bodies can come in all shapes and sizes. It's a lot of fun to draw a variety of characters.

In this section, I will go over the steps to draw the torso and back. The structural shapes will help you construct muscles in these areas as well as add tails to your furry characters.

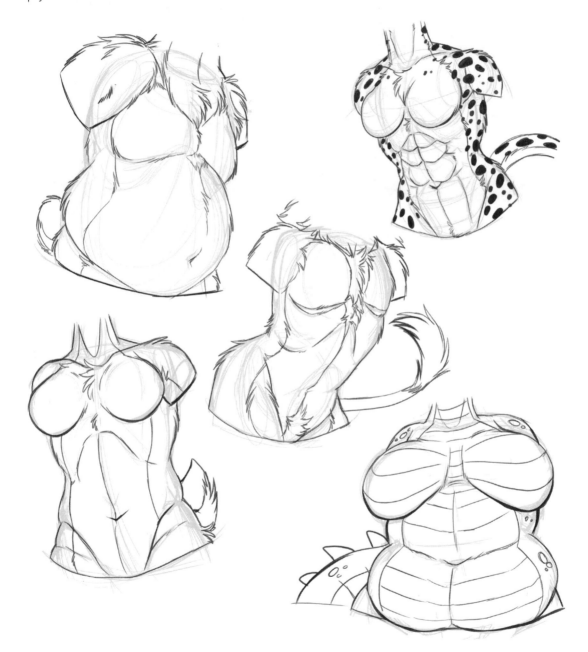

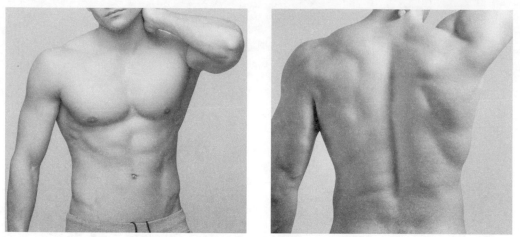

reference photos

Heads are a unit of measurement that artists use to help scale proportion on a body. For this exercise, I'll be using the 8-head proportion scale. Eight heads in total stacked on top of each other would be as long as the entire height of your character. You can increase it to 10+ for superhero/larger proportions.

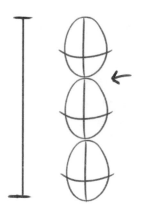

Step 1 Draw your line of action! This is the line that the center of your body will be flowing with in a pose. The heads in the right-side image are to show how the torso is three heads high; no need to draw them, but you can to practice proportions!

Step 2 Sketch in a large box on top and divide it in two. This is your rib cage and pecs. Leave a space for the belly area. Then draw a smaller box on the bottom. These will be your hips.

Step 3 Draw in the rib cage and hips, with circles to mark the locations for neck and leg placement.

Step 4 Add in your basic shapes, breaking down the masculine torso using your reference. Add in the pecs, the neck lines, the abs, and where the legs would start.

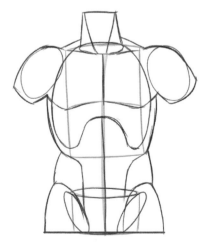

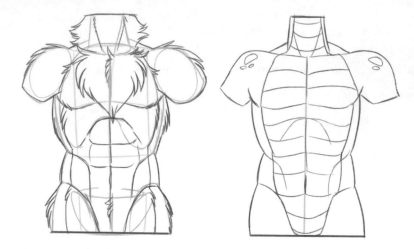

Step 5 Finalize your drawing by stylizing it with furry/scaly touches. Add fur with longer sections on the chest, shoulders, and neck. Or you can add some plated scales going down the front. Draw in markings, and you're done!

Try the same steps for the back view.

BACK VIEW

Steps 1 to 3 Repeat steps 1 to 3 from the body-drawing exercise on page 46.

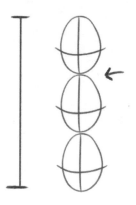

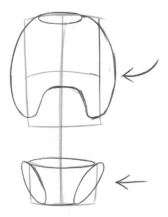

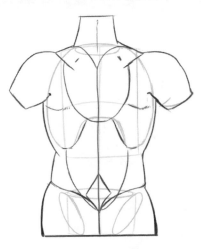

Step 4 Look at your reference and section off your muscle areas.

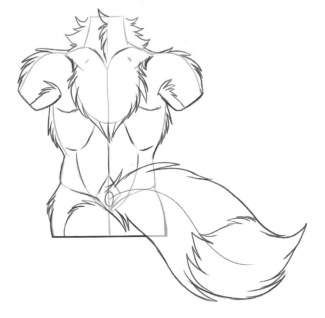

Step 5 Add your character's details, such as fur or scales—you can add in a tail too!

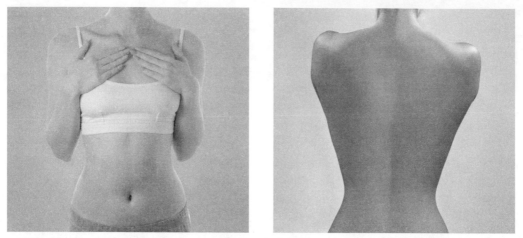

reference photos

Heads are a unit of measurement that artists use to help scale proportion on a body. For this exercise, I'll be using the 8-head proportion scale. Eight heads in total stacked on top of each other would be as long as the entire height of your character. You can increase it to 10+ for superhero/larger proportions.

Step 1 Draw your line of action! This is the line in that the center of your body will be flowing with in pose. The heads in the right-side image are to show how the torso is three heads high; no need to draw them, but you can to practice proportions!

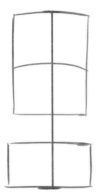

Step 2 Sketch in a large box on top and divide it in two—this is your ribcage and pecs. Leave a space for the belly area. Then draw a larger but wider box on the bottom. These will be your hips.

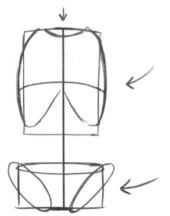

Step 3 Draw in the rib cage and hips, with circles to mark the locations for neck and leg placement. Your rib cage lines should narrow toward the center.

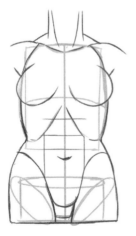

Step 4 Add in your basic shapes, breaking down the feminine torso using your reference. Draw in the neck and shoulders, your abs guidelines, and your breast area (if any!).

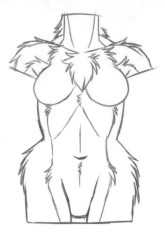

Step 5 Finalize your drawing by stylizing it with furry/scaly touches. Add fur with longer sections on the chest, shoulders, and neck. Or you can add some plated scales going down the front. Draw in markings, and you're done!

Try the same steps for the back view.

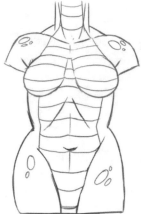

BACK VIEW

Step 1 to 3 Repeat steps 1 to 3 from the body-drawing exercise on page 50.

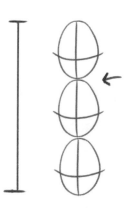

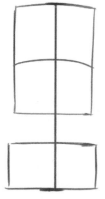

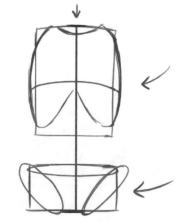

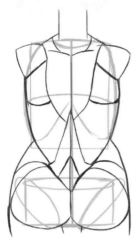

Step 4 Look at your reference and section off your muscle areas.

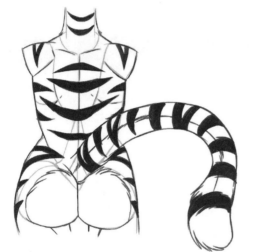

Step 5 Add your character's details, such as fur or scales—you can add in a tail too!

LEGS

The look of your anthro legs will all depend on your style; for example, do you prefer the look of your character to be closer to an animal or human in build?

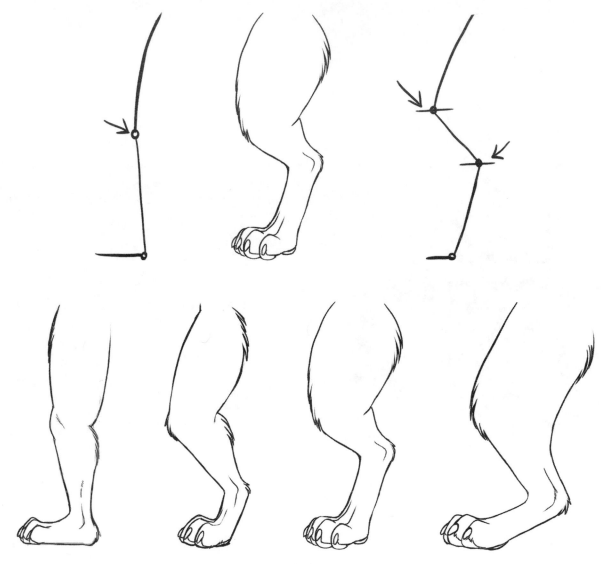

Plantigrade legs

There are a variety of ways to stylize upright animal characters. We can combine animal and human anatomy by creating a combination of *plantigrade* and *digitigrade* leg structures.

Plantigrade legs are like ours. Bears and red pandas also have plantigrade legs.

Digitigrades are like those of a cat or dog; their legs are sectioned differently based on their needs.

Using references of animals standing on their back legs is a great way to help us understand how an upright animal would walk.

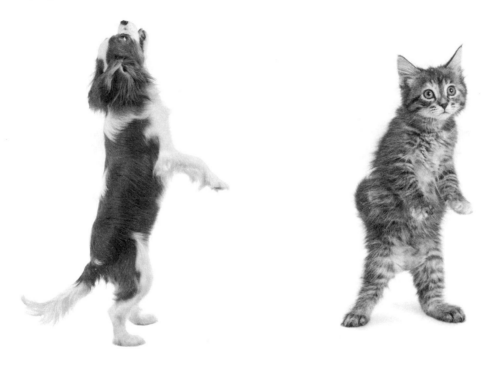

Plantigrade Leg

Step 1 Start with a line down and a circle in the middle for your knee.

Step 2 Add on another circle at the bottom of your line, then draw a line for the foot placement.

Step 3 Draw in simple shapes to break down your leg: top leg can be a rounded cylinder, bottom leg is a mix of circle and cylinder, foot is a trapezoid, toes can be boxes or circles. Then sketch in your knee.

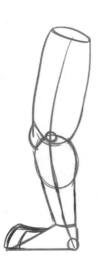

Step 4 Refine and stylize—what makes the leg and weight feel right is alternating the flow of your shapes. Top of the leg is more rounded, while the back of it is more flat, and the reverse for the lower part of the leg. Add in your toes and claw details; detail your ankle.

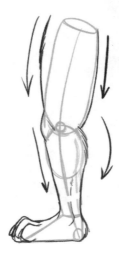

Digitigrade Leg

Step 1 This starts similar to the plantigrade leg. Draw a line down for the top of your leg, and draw a circle at the bottom for your knee. Then draw a shorter line going back with a circle to mark the haunch.

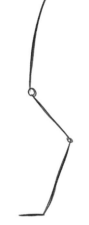

Step 2 Add another line going down. Draw a horizontal line coming from it but shorter than your plantigrade leg, since this is just the part of the character's foot where the paw pads are touching the ground.

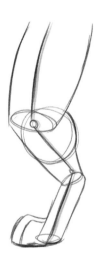

Step 3 Just like the plantigrade leg, draw in your basic shapes—a cylinder for the top leg, ball and cylinder for the bottom, and another cylinder for the lowest section of the leg meeting the feet. Sketch in your toes with boxes.

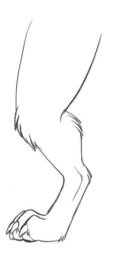

Step 4 Refine and stylize. Draw in your fur or scale details, and add in your nails and paw pads. Detail the ankle, and your digitigrade leg is done!

HANDS

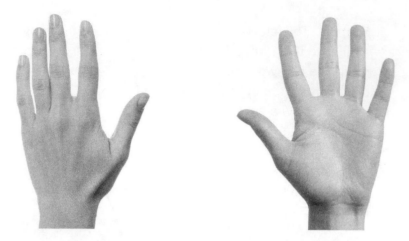

Hands come in a lot of different shapes and sizes. You can stylize your hands, from big cartoony paws to small chibi paws. There are hands that look like a hybrid of human and anthro.

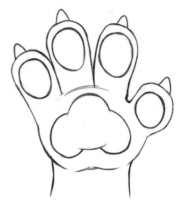

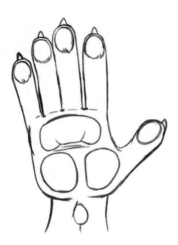

Feline hands will have retractable claws. Here is a close-up example:

Understanding the hand in a 3D space can help with drawing from different angles. For example, see this breakdown of the palm and finger placement in a ¾ view.

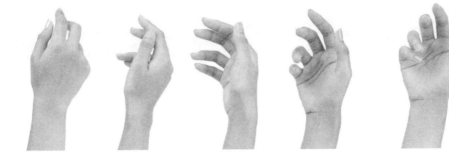

ART TIP Hands are super tricky to understand and draw. The best way is to reference your own hands for practice or search up some references for different angles to draw from. Drawing human hands will help you understand how to draw anthro hands!

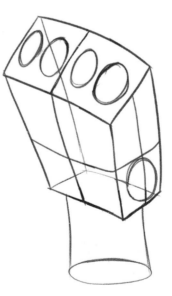

reference photo

Step 1 Start by drawing a box and sketching lines along the halfway marks, vertically and horizontally.

Step 2 On the right side, draw a line coming out from the bottom right of the square. This will be your thumb.

Step 3 Draw a line coming up vertically from the middle (this is as long as the middle finger would be). Sketch an arch over the top. Your fingers get smaller toward the outside; paw hands will have the same look.

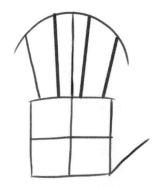

Step 4 Draw four lines (two on each side of the middle line) for your fingers.

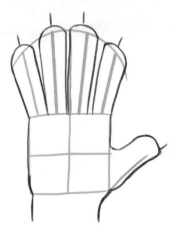

Step 5 Draw in your fingers and thumb. Add little lines in the middle of the tips of the fingers—this is where your claws will be.

Step 6 Add in your claws and paw pads, along with other details.

Do the other side: Do steps 1–5, but instead of drawing the paw pads for step 6, draw in your claws and the knuckles on top of your hand.

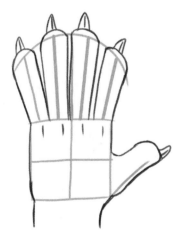

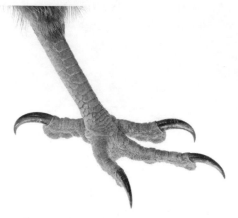

reference photo

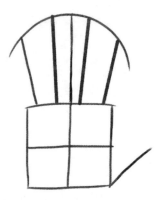

Step 1 Repeat steps 1–4 from the paw-drawing exercise on page 60.

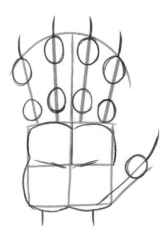

Step 2 Draw circles for your fingertips and another set toward the palm. These are shapes for your fingertips and lower sections. Add another circle on the line below for the tip of the thumb; this one should be shorter than those for the fingers. Draw lines out from the center of the fingertips for claw markers. Put two lines on the bottom for the wrist.

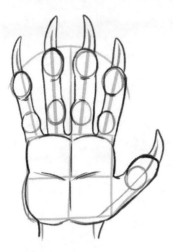

Step 3 Draw in and refine your hand outline, then your claws. Add in palm creases like on a human hand and little lines to mark the parts of the fingers you can bend. Refine your wrist (you can look at your own hands for reference too!).

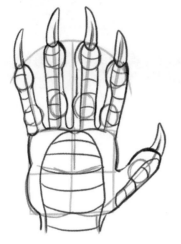

Now for the other side. Repeat steps 1–2 and instead of drawing the palm and bottoms of the fingers, you can draw the details on top of the fingers, the knuckles, and how the claws would look from the top. Some avian characters have plates on the top in different styles. You can also use this type of hand for dragons, dinosaurs, and reptile characters!

Hooved Hands

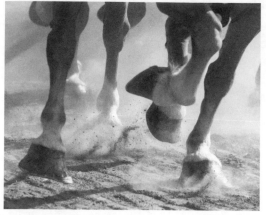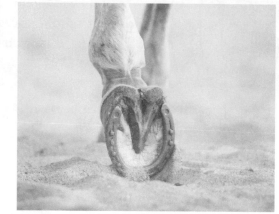

reference photos

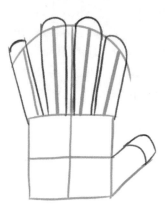

Step 1 Repeat steps 1–5 from the paw-drawing exercise on page 60 to structure your hand like this.

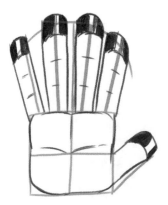

Step 2 Section the fingertips off for horse hooves. You can also fill them in. Draw your palm lines or your knuckles depending on which side of the hand you are drawing.

2A: Some horse characters will have full hooves for hands. You can use the same hand breakdown to draw the hooves.

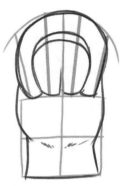

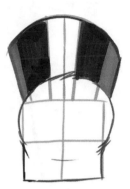

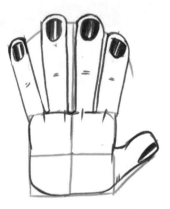

2B: Others will have the hooves as the tips of the fingers like the steps before, or simply as fingernails.

FEET

I covered feet a bit earlier in the leg section, but here is a breakdown of the feet more up-close—and different ways to draw them in various angles.

Depending on what you prefer, there are multiple ways to draw feet. You can make them as animal-like or human-like as you want, and they still look great!

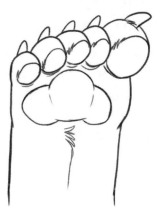 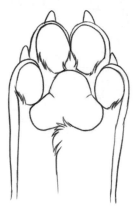

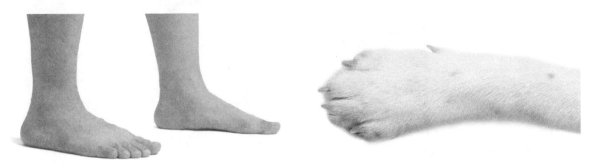

reference photos

Step 1 Start by drawing a 90-degree angle with circles at the bottom and the left for heel and toe placement.

Step 2 Draw a trapezoid for your foot shape. Your heel and toes will both be touching the ground.

Step 3 Add on boxes or circles for toe shapes.

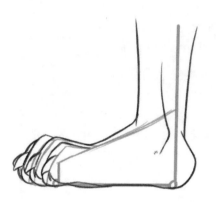

Step 4 Add your final details, ankle, claws, and paw pads.

Digitigrade Paw (Animal-Like)

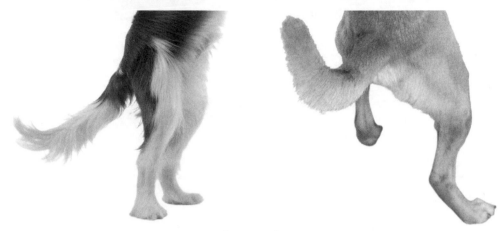

reference photos

Step 1 Draw a longer line going down diagonally and a shorter line coming from it. This will be your haunch and toes. Draw another line on top of the taller vertical line; this can be part of the leg, but you do not need to draw the entire leg for this exercise.

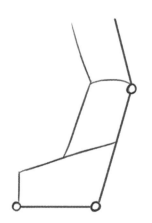

Step 2 Sketch in some basic shapes to break down the sections.

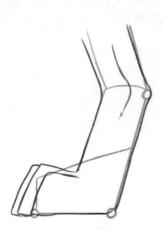

Step 3 Add in your toes and ankle, detail the linework, and stylize your feet.

Step 4 Finalize with details like fur, paw pads, and claws, and you're done!

Paw (Human-Like)

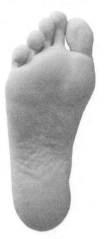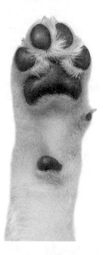

reference photos

Step 1 Using similar steps to the plantigrade foot, let's do this one where the foot is facing the viewer.

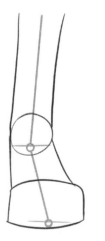

Step 2 Block in your basic shapes, adding a circle for the heel, a rounded rectangle for the toes, and lines connecting the feet to the heel and up to the leg.

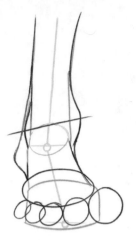

Step 3 Draw in your ankle line, and add in the ankle (it is higher on the inside of the foot than the outside!). Add in circles to show the toes; have the one on the inside be the largest, with the smallest on the outside.

Step 4 Detail in your claws, paw pads, and lines!

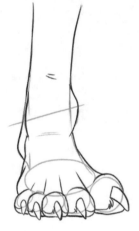

Bottom of Paw

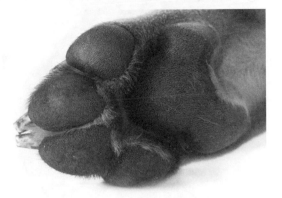

reference photo

Step 1 Draw a vertical rectangle and divide it into four quarters.

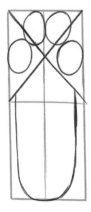

Step 2 Add an X. This will be a guideline of where to place your paw pads. Draw in the rest of the foot and heel at the bottom of the X to the bottom of the rectangle.

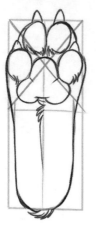

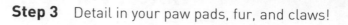

Step 3 Detail in your paw pads, fur, and claws!

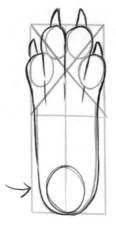

Other side: Repeat steps 1 and 2, and then draw the other side! The paw pads will not be showing on this side. You can also draw in a circle at the bottom to place where your leg would connect.

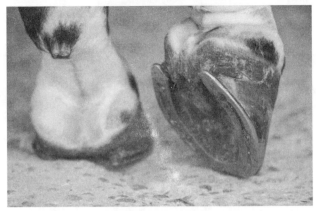

reference photo

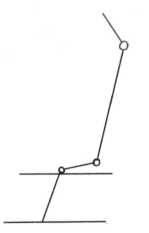

Step 1 Start by doing similar lines to a digitigrade paw, but this time underneath will be a section for the hoof. Draw a line underneath to mark the ground.

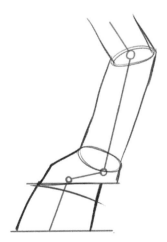

Step 2 Add in cylinders and the trapezoid above the hoof, and add in a hoof line and two diagonal lines down to the ground line.

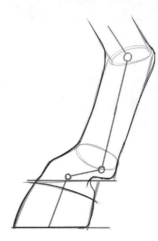

Step 3 Looking at your reference, refine your lines and shapes.

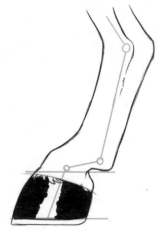

Step 4 Fill in your hoof if you'd like, and add short hairs around the hoof line. Detail your ankle and your drawing is complete.

Step 1 Draw a vertical rectangle and add a T into the middle. The horizontal line should be about 1/3 of the way down, with the vertical line dividing the space under in half.

Step 2 Sketch in the shape of the hoof. Draw in the rest of the foot hoof in a U shape for the heel and the two lines meeting the hoof; this shape is a bit narrower than the horseshoe width.

Step 3 Using your references, refine your lines and add in some fluff if your horse has it. You can also add in fancy horseshoes, if you'd like!

Talon Feet

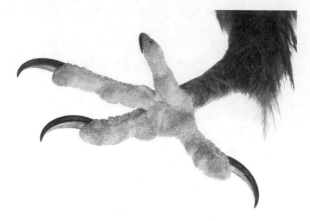

reference photo

Step 1 Let's draw a digitigrade talon foot facing toward the viewer. Using the same steps to get the digitigrade leg lines, I'm drawing the lines like so—thinking of how the foot would work in 3D. Draw a line at the bottom for the ground.

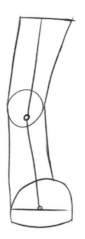

Step 2 Break down your leg into shapes and sections. A circle for the heel, and cylinders for the foot and leg sections. Draw a half-circle shape for the toe area.

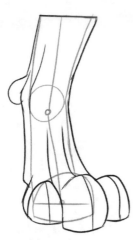

Step 3 Draw over and refine your lines. Add a part in the back for the rest of the foot. Sketch in a stump for the back claw and the ankle line. Using smaller half circles, draw in the toes and connect them up into the foot. Draw lines down the middle of the toe tips.

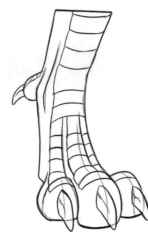

Step 4 Refine your lines and add in plating, claws, and marking details.

Hooked Claws

Another way to draw the claws for bird feet and dinosaurs: add in hooked claws!

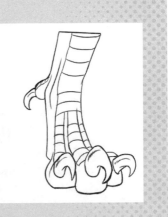

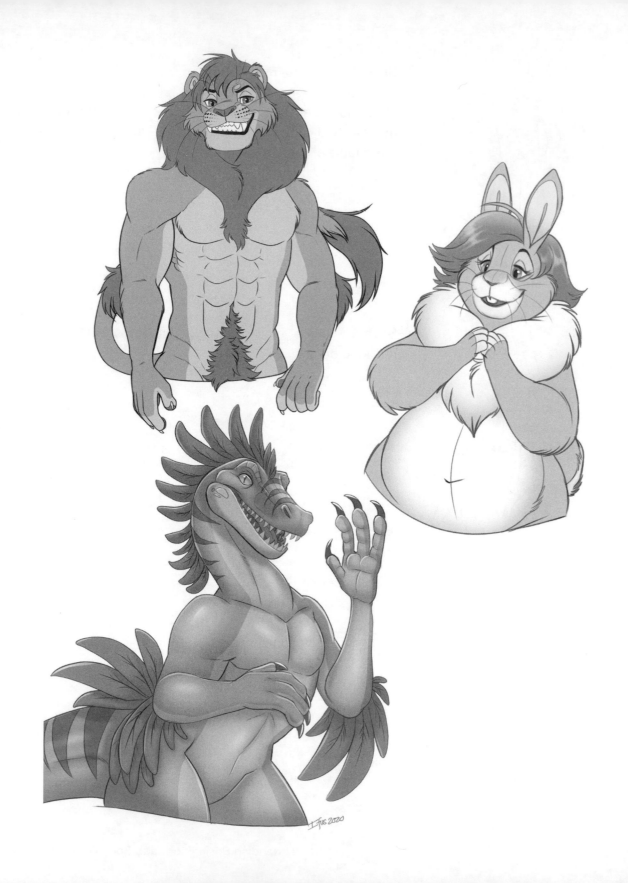

Half-Body Drawings

Now we are going to take everything we learned in the first section and make half-body drawings. Half-body drawings are great for character badges and for showing more of the personality of a character, without drawing the entire body.

These characters will be constructed with a variety of builds and body types. Each will feature traits from both human and animal anatomy, but feel free to stylize in whichever way you prefer—or experiment to see what you like best!

Cat

reference photo

Step 1 Draw a head circle and a line going down in the direction of your pose. This is your line of action, and it follows the spine.

Step 2 Next section off your torso like you practiced in Section 1. Add your rib cage and hips. Draw in your linework for arms, adding circles to mark the shoulders, elbows, and hands.

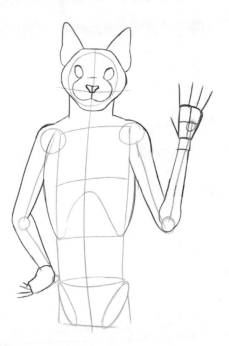 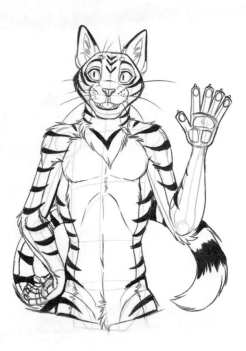

Step 3 Next start to draw in your handpaws like you practiced in Section 1. Add your arm shapes. Drawing cylinders helps with the perspective of arms, if things get hard to figure out. Define your face with a muzzle, nose, and circles for eyes. Add on the ears.

Step 4 Finish your cat by adding fur, markings, and whiskers. Detail your eyes, ears, and muzzle. Draw on your cat's paw pads and claws, then you're done!

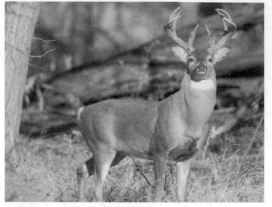

reference photo

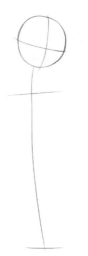

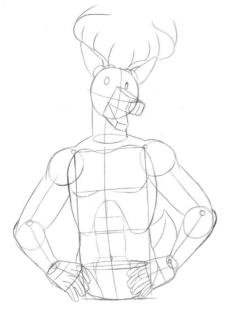

Step 1 Draw your head circle and line of action.

Step 2 Draw your body as you have practiced in Section 1. Make sure to section off the muscles for the abs on the torso. Use cylinders and circles to create the shapes of the arms. Draw in your basic shapes for your deer head. Draw lines showing the form and size of your antlers. It's best to start with some simpler lines and then build from those!

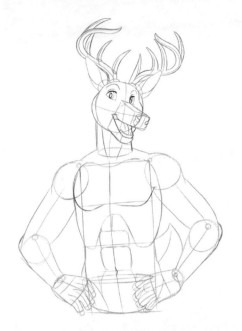 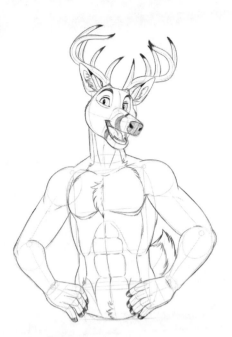

Step 3 Detail and stylize your face. Draw outlines around your antler lines ending the branched sections in points.

Step 4 Refine your lines; add in markings and some light linework to show muscle definition. Finish with fur detail on the tail and some short hairs on the face and chest.

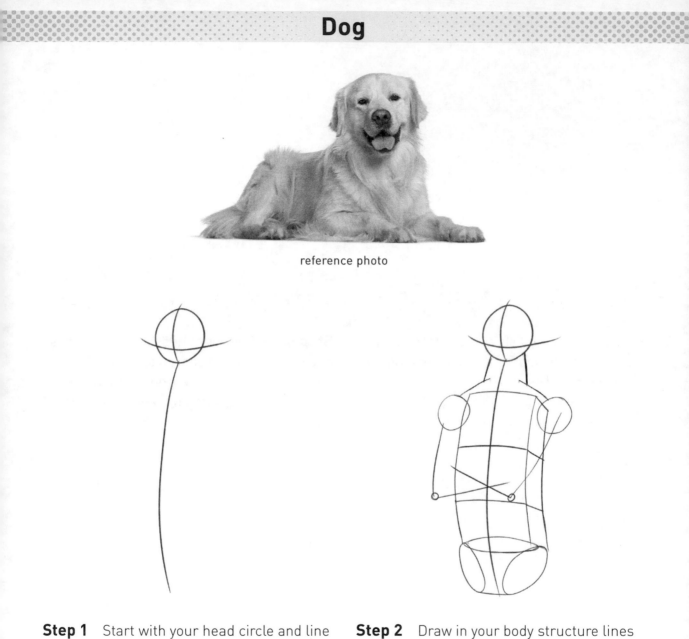

reference photo

Step 1 Start with your head circle and line of action.

Step 2 Draw in your body structure lines and lines for the arms.

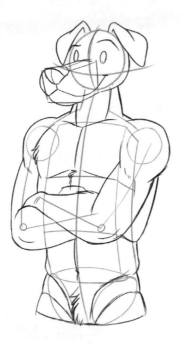

Step 3 Draw in your basic shapes for the face, muzzle, ears, arms, and torso.

Step 4 Stylize and detail!

Fox

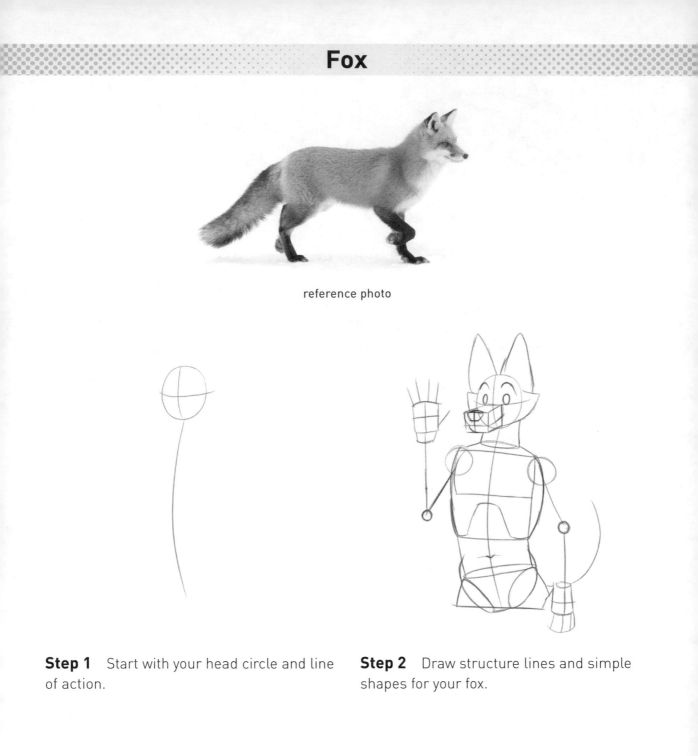

reference photo

Step 1 Start with your head circle and line of action.

Step 2 Draw structure lines and simple shapes for your fox.

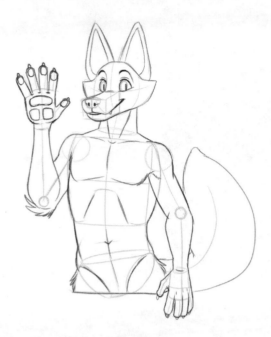 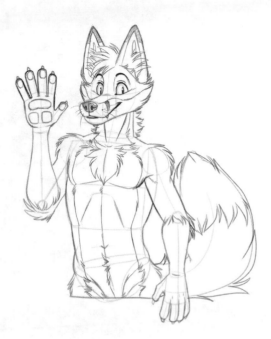

Step 3 Stylize your eyes, muzzle, and body; add in the basic shape and size of the tail. Add paw pads and claws to the hand.

Step 4 Finish with final details and make that tail super fluffy!

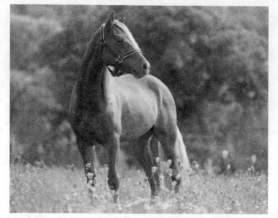

reference photo

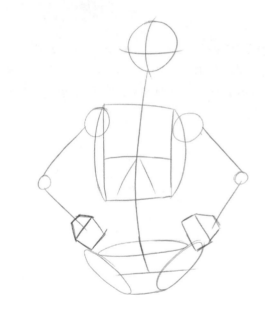

Step 1 Draw your head circle and line of action.

Step 2 Draw in your structure lines, and position your arms to have the hands on the hips.

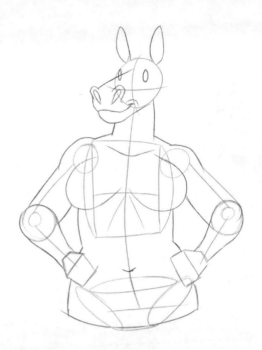 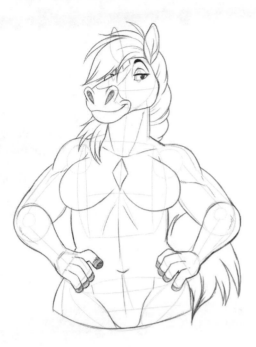

Step 3 Start to form the body with basic shapes. Using the reference, add in your muzzle, ears, and eyes.

Step 4 Detail and add in your mane, and finish with markings.

Lion

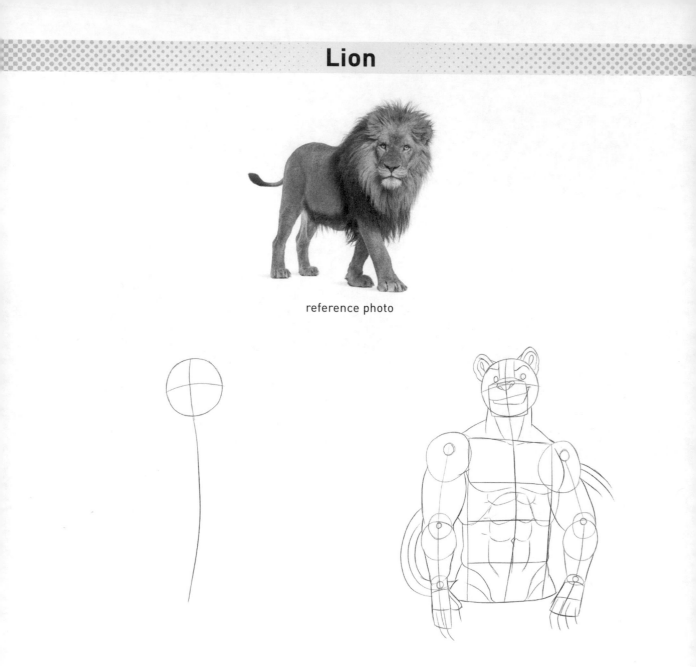

reference photo

Step 1 Draw your head circle and line of action.

Step 2 Using what you practiced in Section 1, draw in your torso and basic head shapes, and section off your muscles. Draw in your tail shape.

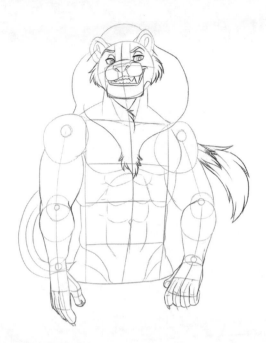

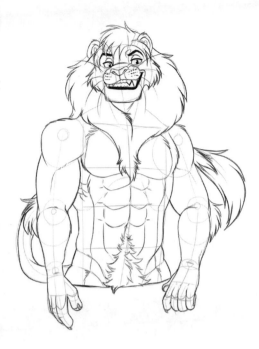

Step 3 Stylize your face and expression. Add in basic shapes for the mane, and draw in the fluff at the end of the tail.

Step 4 Finish with markings, whiskers, mane, and fur detail. Refine your muscle lines—and your lion is complete!

Rabbit

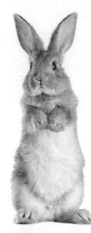

reference photo

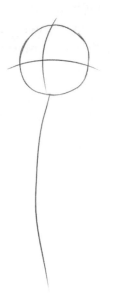

Step 1 Start with your head circle and line of action.

Step 2 Draw basic shapes and structure lines.

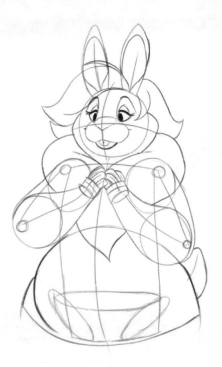

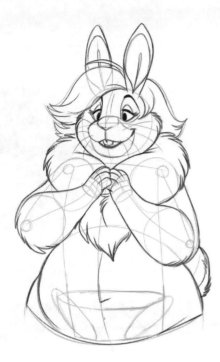

Step 3 Draw in your eyes and hair shape, and detail the ears. Add in some fluff around the neck!

Step 4 Detail the fur, hair, and face. Add in whiskers, and you're done!

reference photo

Step 1 Draw a head circle and line of action.

Step 2 Sketch in structure lines and basic shapes to get down the build of the body and face. Draw in your lines for arms and add the hands.

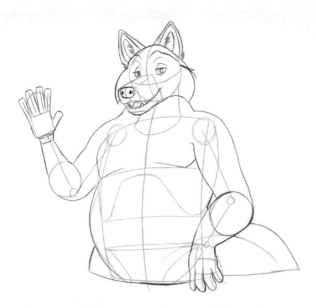

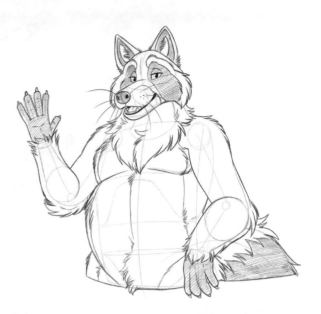

Step 3 Start to stylize your face and body—draw in your fingers, detail your ears. Add in the shape of the tail.

Step 4 Finalize with fur details and markings!

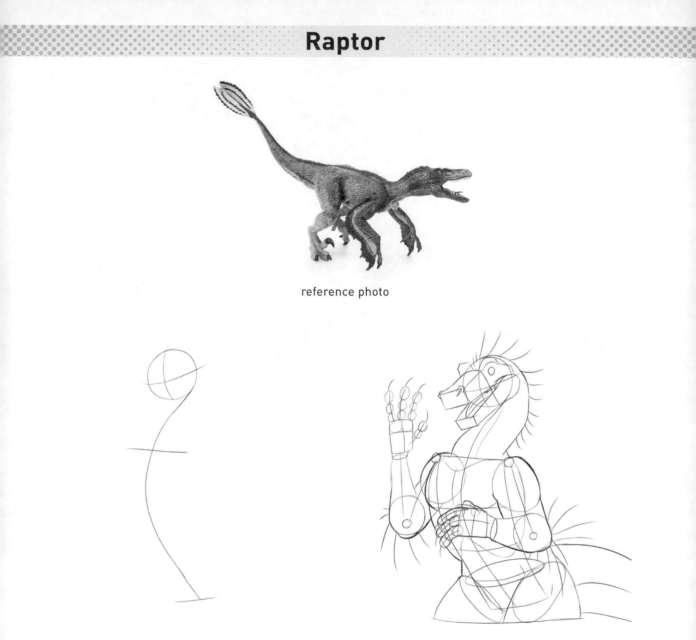

reference photo

Step 1 Draw your head circle and line of action.

Step 2 Sketch in your basic shapes—this one will be more difficult since it's very detailed. Continue with simple shapes and lines for the fingers, claws, and feathers.

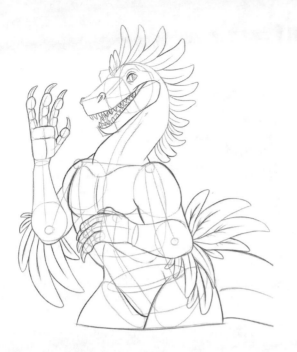

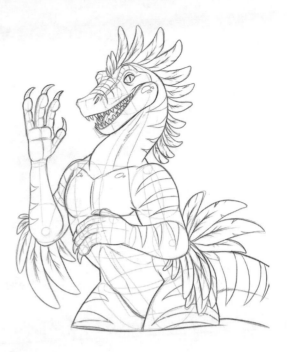

Step 3 Stylize and refine your lines. Add in the feathers and teeth!

Step 4 Finalize the scale details and markings; add in some lines to detail the feathers.

Wolf

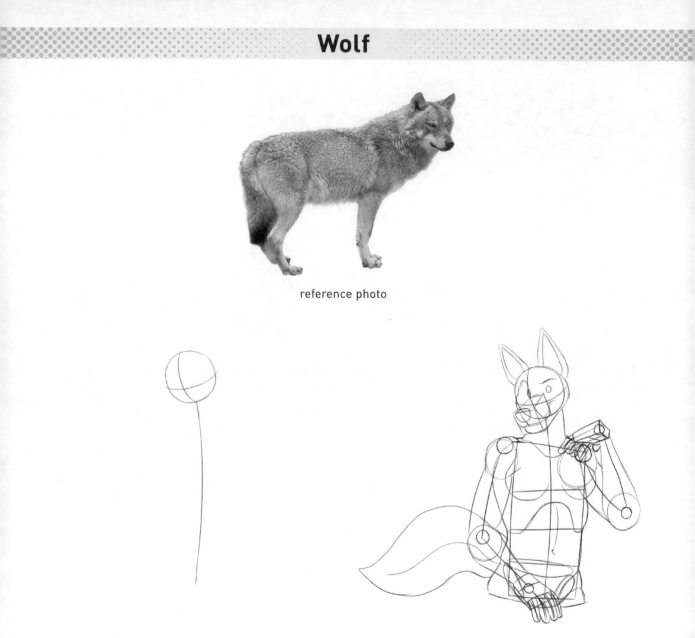

reference photo

Step 1 Start with your head circle and line of action.

Step 2 Structure your drawing with basic shapes.

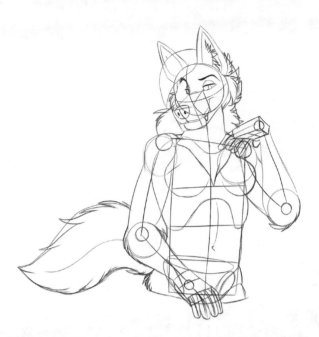

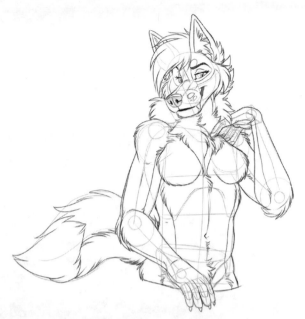

Step 3 Stylize and detail your face and body; add in the fur for the tail and simple shapes for the hair.

Step 4 Finalize and detail your fur, hair, and markings.

Full-Body Drawings

This section will be the most challenging—drawing the full body! Though, with practice, it will get easier. If you want to jump to this section right away, then go right ahead! For beginner artists, I recommend practicing the individual parts and half bodies so that this section is easier to do. There are so many different body types to draw—I'm going to show you how to draw a variety of them.

ART TIP There are several places online for anatomy practice, including doing a simple search for "figures." I recommend *Atlas of the Human Anatomy for the Artist* by Stephen Rogers Peck, *Force* by Mike Mattesi, and *Dynamic Anatomy* by Burne Hogarth.

Bat

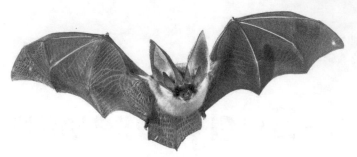

reference photo

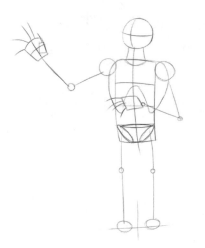

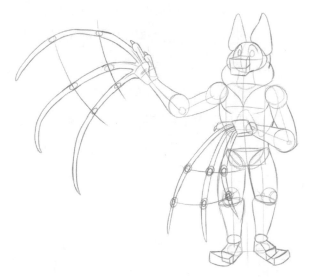

Step 1 Draw your line of action for the entire body, and sketch in your basic shapes for body structure. This one is a bit different, since the hands will become the wings!

Step 2 Lengthen your fingers super long—wings are like extended hands and arms. This bat design combines both the wing and the arms. The circles and lines sectioned off are like the sectioned parts of the hand.

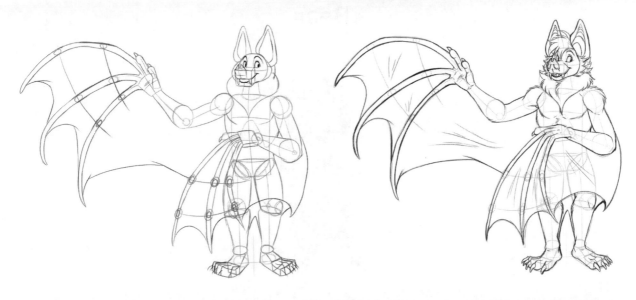

Step 3 Add in the wing webbing; stylize your face and body.

Step 4 Finalize and detail your bat with hair and markings. Refine the fur, and your bat is complete!

Bear

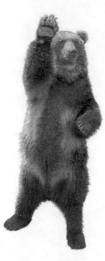

reference photo

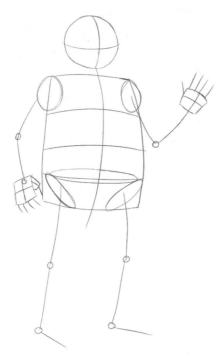

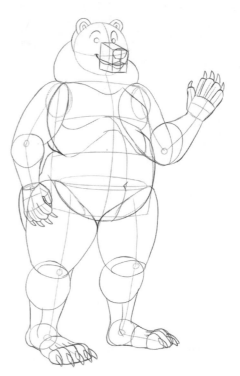

Step 1 Start by drawing your basic body structure guidelines.

Step 2 Sketch in basic shapes to build the body and face. Add in your fingers and toes, and draw in claws on the feet and paws.

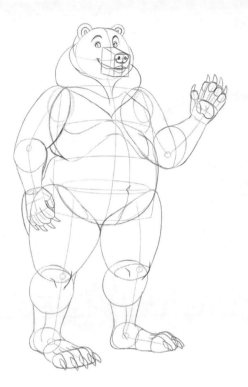

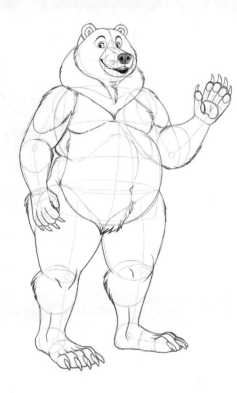

Step 3 Stylize your face, add on paw pads, and refine your body lines.

Step 4 Finish with fur detail and markings!

Cobra

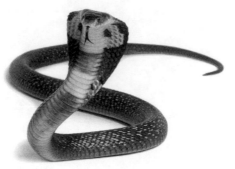

reference photo

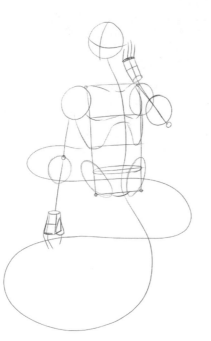

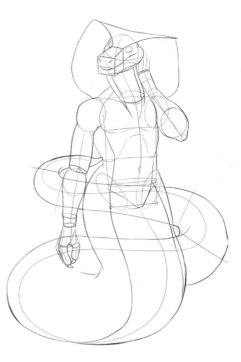

Step 1 This is one of the more different body types, yet the easiest to attempt since this character will not have legs, but a long body like a snake! These characters are sometimes called *nagas*. Start with your basic body structure shapes and lines. Draw in the head to waist as usual—but instead of drawing in legs, draw a long line going back and wrapping around.

Step 2 Sketch in the snake's hood and basic shapes for the torso and arms. Then have the body gradually get thinner from the thickness of the hips, like the snake reference image.

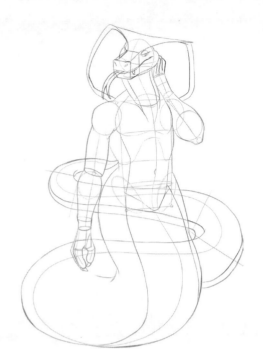

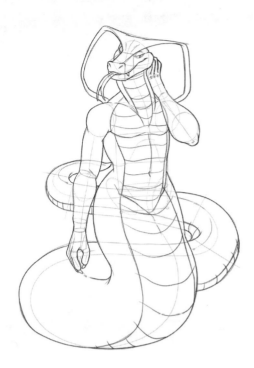

Step 3 Stylize your face and body. Refine your lines and add in a long, forked tongue.

Step 4 Finish by adding in the bottom plates going down the underside of the neck and body, and by finalizing your linework.

Dragon

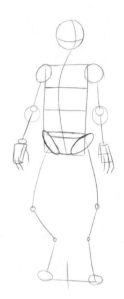

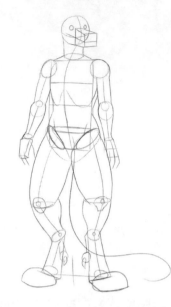

Step 1 Start with your head and line of action. Begin to build the body lines.

Step 2 Construct simple shapes for your dragon's body, and add a line for the tail.

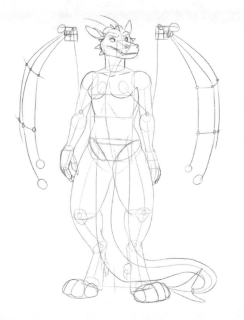

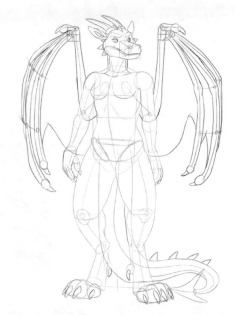

Step 3 Start to detail the body and add structure lines for the wings. To see more detailed instructions about drawing wings, you can look over the wing part in Section 4.

Step 4 Detail your wings and add the claws to the ends of the wing "fingers," then add the webbing. Add claws to your dragon's toes.

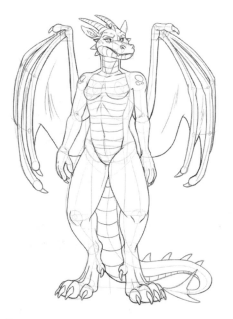

Step 5 Add in plating details, ridges on the horns, and scales. Your dragon is complete!

Bird

reference photo

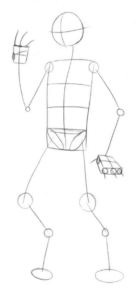

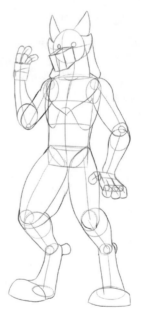

Step 1 Draw your body structure lines.

Step 2 Sketch in your basic shapes, making sure to use the same technique for drawing muzzles for the beak.

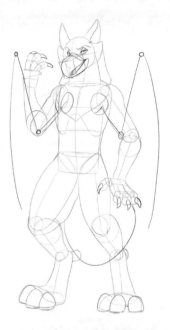

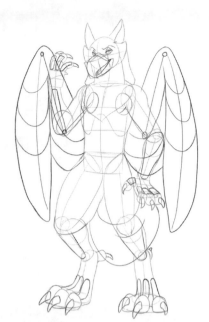

Step 3 Detail your beak and eyes. Add claws. Sketch in structure lines for the wings. This time, instead of the wings being a part of the arm, I will put them on the back. To see more about wing placement, look over the wing part in Section 4.

Step 4 Add in guidelines for your rows of feathers. Add plating sections for the tops of the hands and feet. Make a shape in the back for your bird's tail.

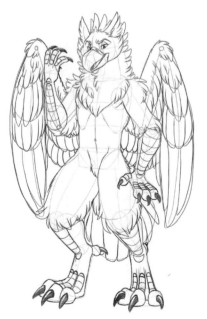

Step 5 This part involves a lot of detail due to the feathers on the wings and details of feathers on the body—but it's worth taking the time to do them! Finish the plating and add any desired markings. Your anthro bird is done!

Kangaroo

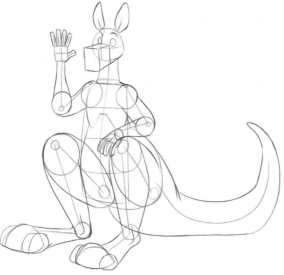

reference photo

Step 1 Draw in your structure lines, using images of kangaroos as reference. They have big, long legs for leaping, and big tails. Their top half seems anthro enough, so it's easy to turn them into a furry character.

Step 2 Start to build your body with simple shapes, breaking down the big legs and adding some anthro arms to the top half. This kangaroo character's posture is a bit more upright.

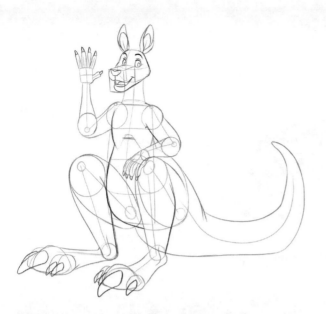

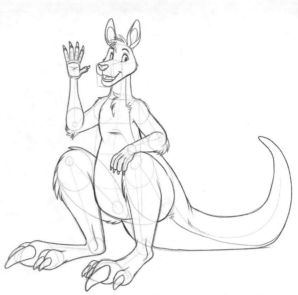

Step 3 Stylize and refine your body lines and face. Add in claws on the hands and feet. (For accuracy, kangaroo inner toes are actually two smaller toes, unlike the one smaller toe on the outside. Some choose to stylize this into one toe for cartoony simplicity.)

Step 4 Finalize and refine your lines, adding a little hair on top of the head. Detail the hands, and you're finished!

Otter

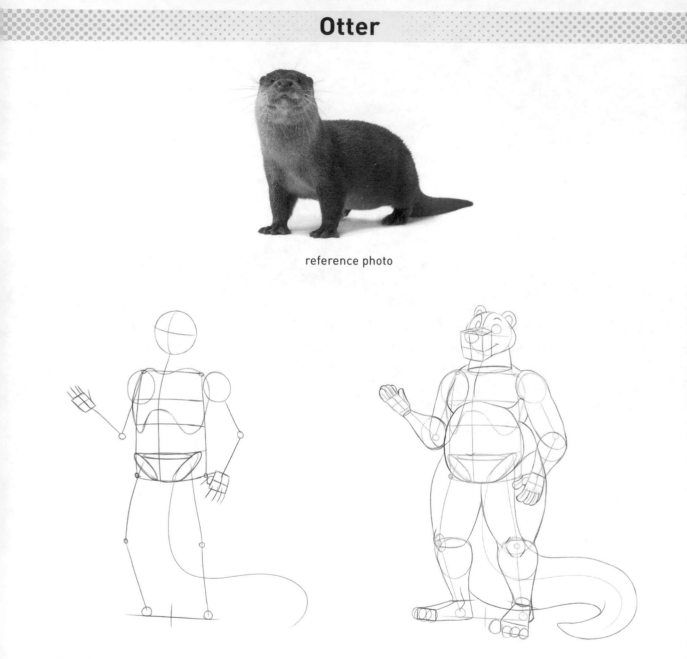

reference photo

Step 1 Start with structure lines and simple shapes.

Step 2 Continue to build your drawing with shapes to define the body and head.

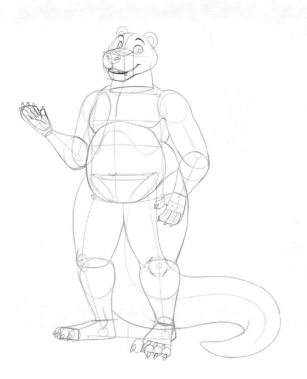

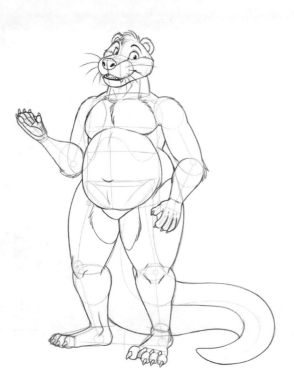

Step 3 Start to stylize your face; detail the hands and claws, and add webbing.

Step 4 Finalize with fur detail, markings, and lots of whiskers!

Skunk

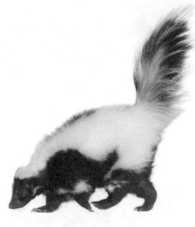

reference photo

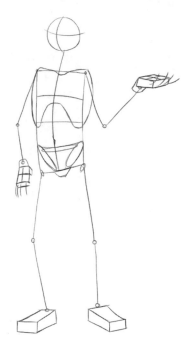

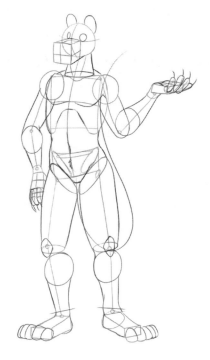

Step 1 Start with your line of action and body structure shapes.

Step 2 Detail in your shapes. Add fingers and toes, and make a big line in the back for the tail.

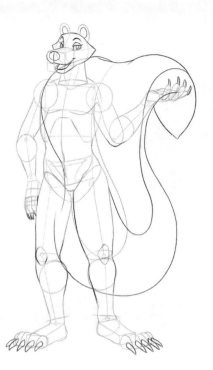

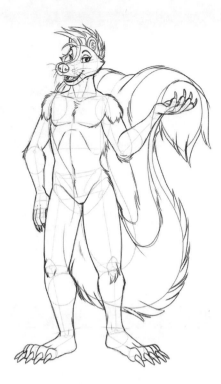

Step 3 Stylize and add in your refined face lines. Draw in your big skunk tail. Add claws!

Step 4 Finalize your skunk with a personalized haircut, whiskers, nostrils, and fur details.

Tiger

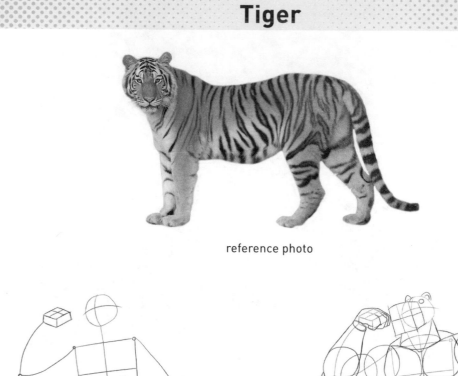

reference photo

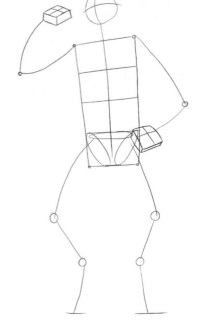

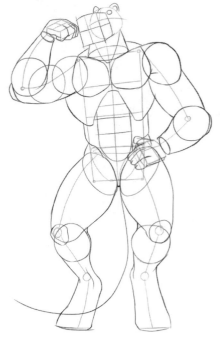

Step 1 Start with your line of action and structure lines.

Step 2 Block in your muscles and use simple shapes to section off where the muscle lines will go. Start to build the face.

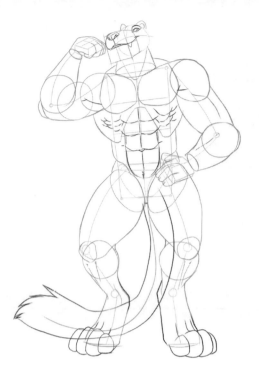

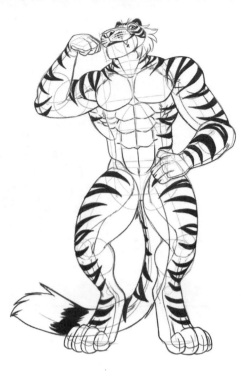

Step 3 Stylize and refine your lines. Muscles do not need to be completely drawn in. Since they are under fur/skin, they are partially seen but not completely raised up.

Step 4 Refine your lines and add in your stripes and spots! Make sure to wrap your stripes around your muscles for a nice effect.

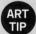 **ART TIP** Look up references for the body types you are trying to draw, for the best accuracy.

Unicorn

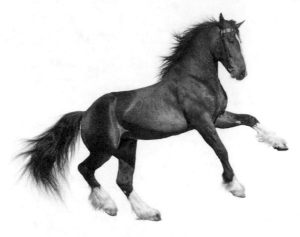

reference photo

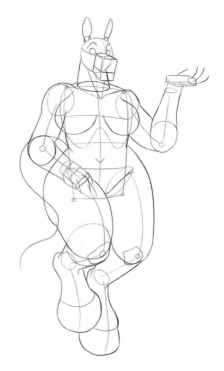

Step 1 Draw your beginning body structure sketch.

Step 2 Start to build your body with simple shapes. This character will be in a magical floating pose, so you don't need to worry about them looking off balance.

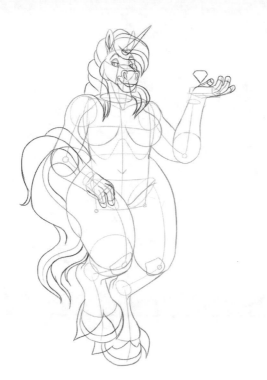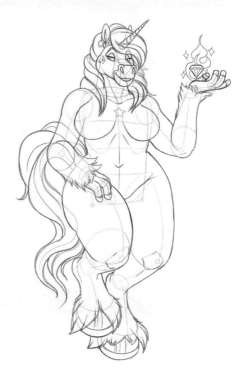

Step 3 Draw on your horn, add a gem in the hand. Sketch on your tail and simple shapes for longer fur around the hooves. Detail the fingers!

Step 4 Refine the lines on your unicorn and add markings; draw ridges on the horn, and fluff on the arms and legs.

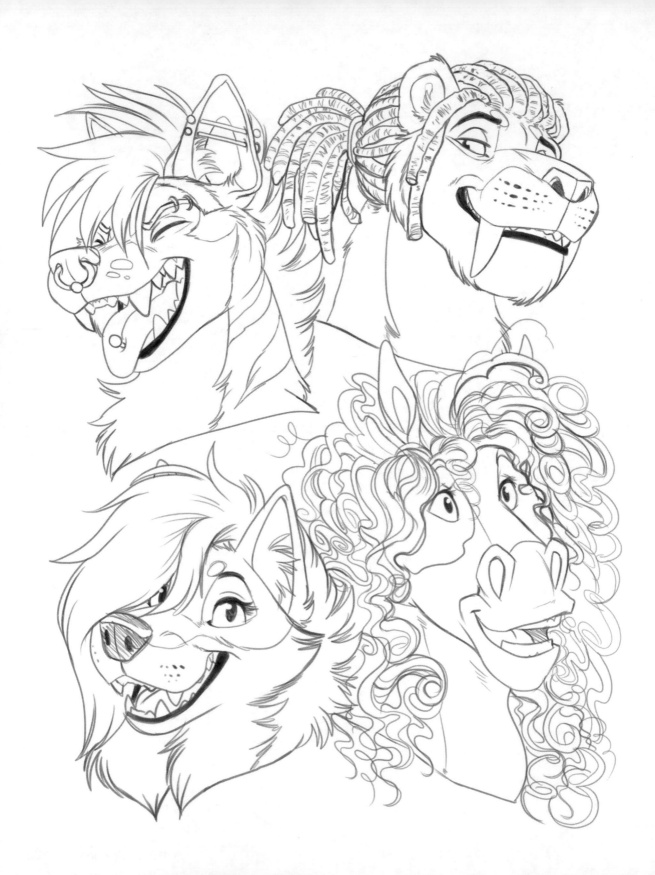

Give Your Drawings Personality

In this last section, I will be covering accessories and personalization of furry characters. Your fursona can be as animalistic or human as you'd like. I will cover clothing, hairstyles, markings, wings, tails, and taur bodies—more detailed and advanced things to add to your characters! They add a personal touch and will be an expression of your aesthetic.

HAIRSTYLES

Hair is one of the big ways a person can show their aesthetic and personality—adding this to a fursona can make them feel more like you!

Hair Roots

Here are examples of where the roots of the hair start on an anthro head.

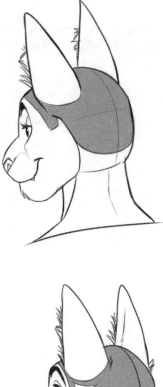

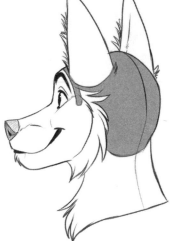

Imagine this area as EXTRA-long fur because, in a way, it is! Here are examples of different hairstyles you can create using this as a guideline.

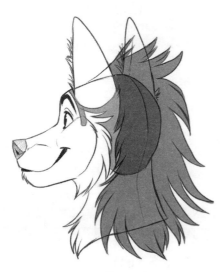
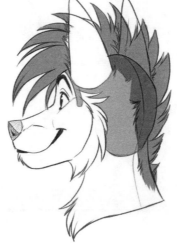
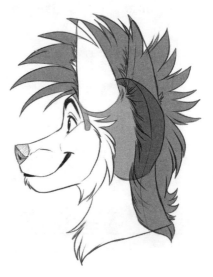

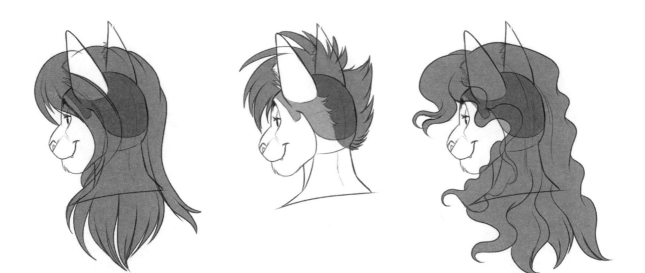

Braids and Beard

You can combine human hairstyles with animal fur and hair to make your designs.

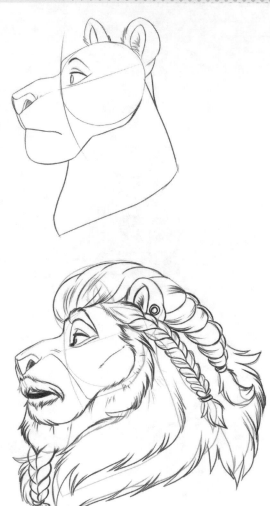

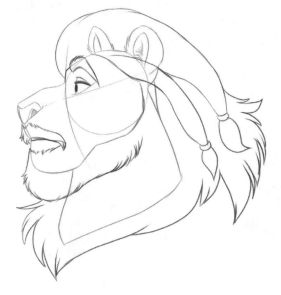

Braids can seem complicated, but if you break them down, they can be easy!

Repeat these shapes down the sectioned line you make for yourself.

Curly Hair

Curly hair is a really detailed task, but if you take the hairs and sketch them lightly and loosely—you can refine the shapes and render a beautiful head of curly hair!

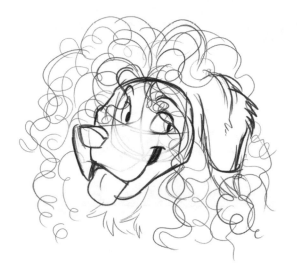
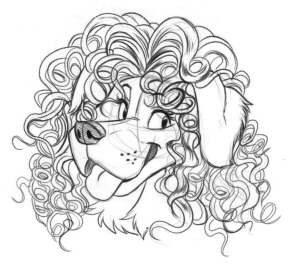

If you break down the curl, it's easier to understand.

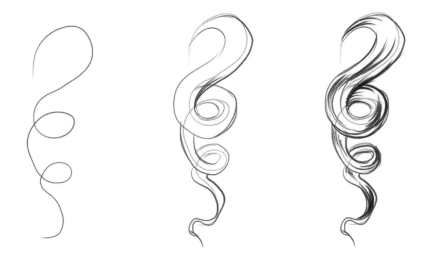

TAILS

Similar to the eye part in Section 1, tails are fairly simple to draw and don't require too much explanation. All of the tails start with a circular base where the shape of the tail will connect with the body. Then you add details like fur, markings, and scales.

Bear Tail

Curly Dog Tail

Deer Tail

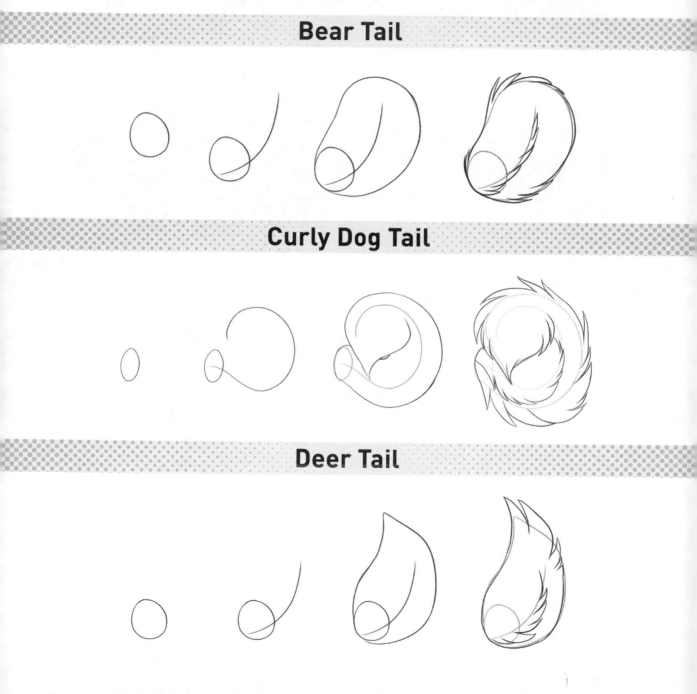

Dragon Tail

Lion Tail

Tiger Tail

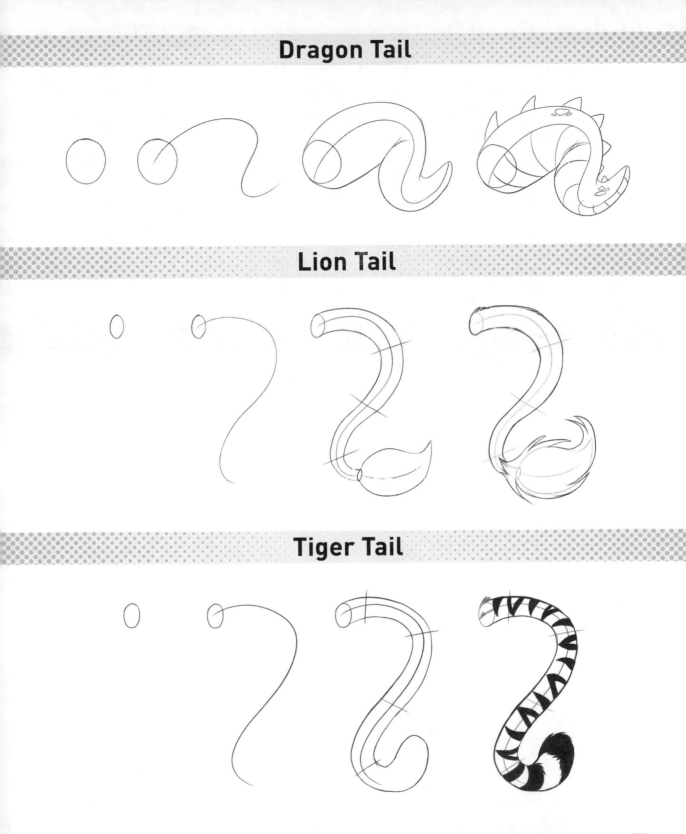

Tail Placement

The tail attaches to the base of the spine. Make sure to place the base center of the tail at the circle with the X, but larger or fluffier tails can take up more space.

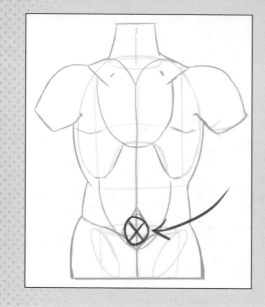 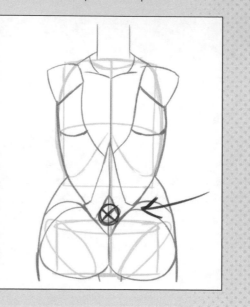

CLOTHING

Clothing for furry characters is an interesting subject, since it sometimes needs to be modified to fit in the furry world. Here are some examples of clothing furry characters can have.

- Slices in the hat for ears to fit.
- Helmets made to fit specific species.
- Pants crafted for those with tails.
- Shoes made for digitigrade feet.

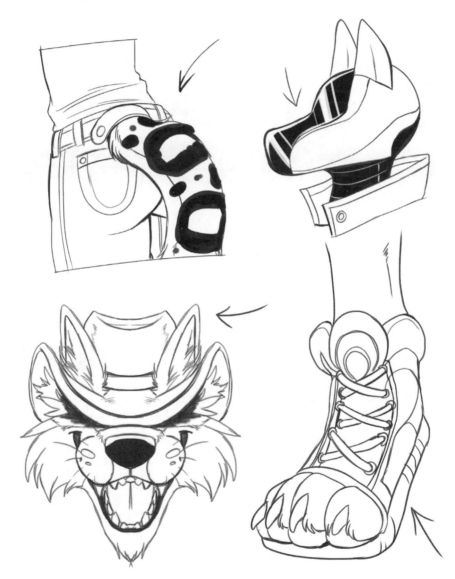

Hot-Weather Clothes

Start with drawing a base of your character for you to draw clothes over! You can use the steps in Section 3 to make this. Don't worry about detailing markings too much though—you may be drawing clothes over them.

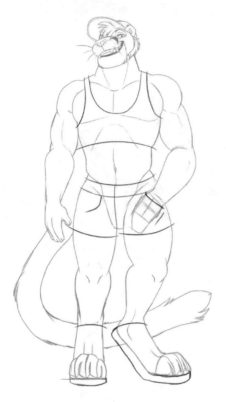

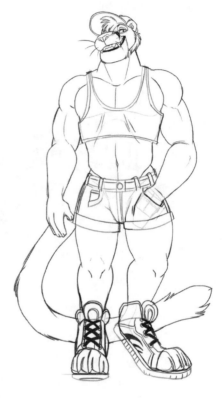

Step 1 Start off by drawing the outline of the neckline, and where your clothes are sectioned off, and end on your character's body.

Step 2 Finalize the crop-top and shorts, detail your shoes, and add your seams.

Cold-Weather Clothes

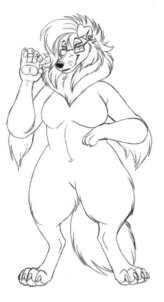

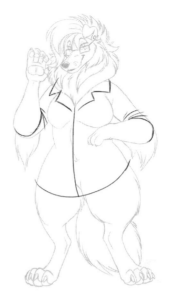

Step 1 Start by drawing in the collar area, a line down the middle for the button-up shirt, and the folds of the rolled-up sleeves.

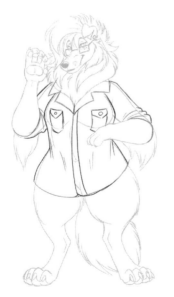

Step 2 Clothing lies on top of and falls from the body; sketch on your shirt and detail your pockets.

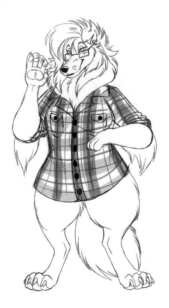

Step 3 If desired, draw on a pattern. I like plaid shirts, so I made this one plaid. Add the buttons, and you're done!

Fantasy Outfits

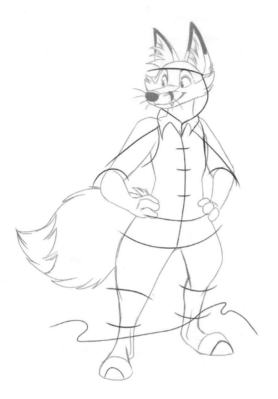

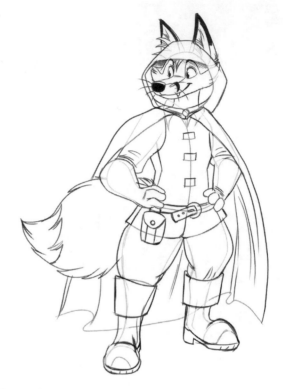

Step 1 Start off by drawing the outline of the collar, and drawing where your clothes are sectioned off and end on your character's body. This type of outfit has a lot of layers.

Step 2 Detail your clothing; add in the seams, buttons, and folds!

WINGS

Some characters have wings naturally and others don't—but furry characters can have wings even if their species in real life doesn't. Creativity when designing characters is endless!

Feathered Wing

Step 1 Draw out structure lines as if you were drawing an arm—wings are very similar!

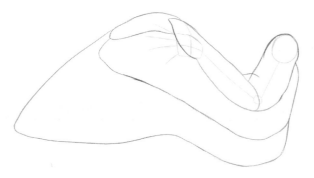

Step 2 Draw your guidelines for the layers of feathers. The top row is the smallest, the second is medium sized, and the bottom has the large feathers on the end that gradually get smaller toward the inside.

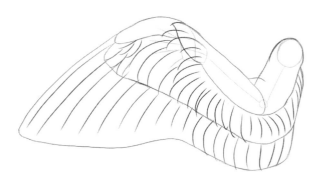

Step 3 Start to draw in placement for your feathers.

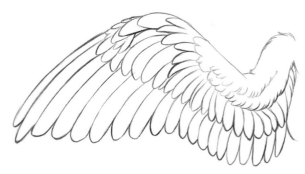

Step 4 Refine and detail your feathers, and your wing is complete. This part is very detailed and will take some time!

Webbed Wing

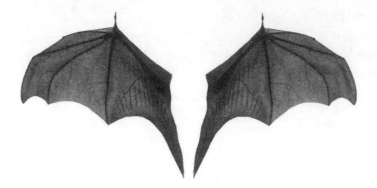

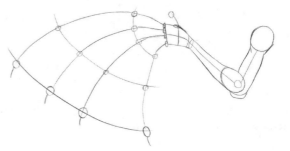

Step 1 Webbed wings are simpler and are often found on dragons, bats, and gargoyles. Start the same as you did with the feathered wing and sketch out some arm structure shapes.

Step 2 Extend out the lines for the fingers and mark the bending areas with circles. I drew a line across each section to make sure they line up.

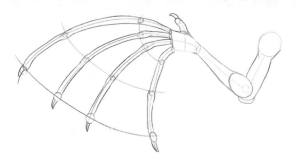

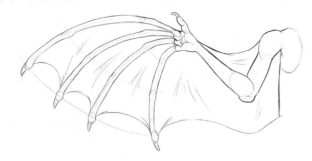

Step 3 Refine your shapes and add in the "thumb" claw up on top.

Step 4 Detail your hand area and add in the webbing!

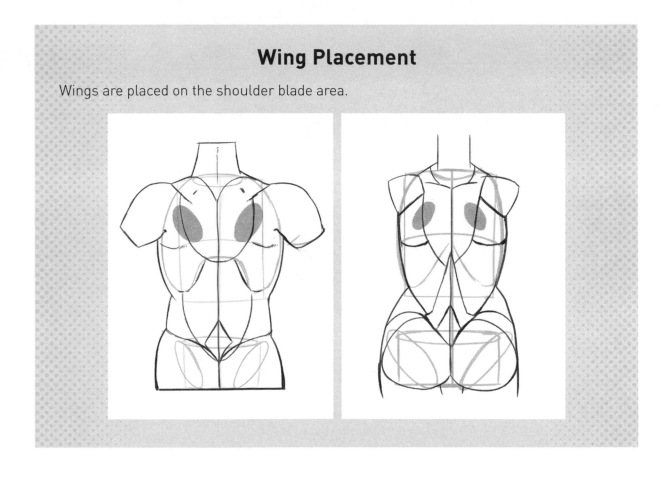

Wing Placement

Wings are placed on the shoulder blade area.

MARKINGS

Markings are a way to personalize your characters, make them look more or less like their species, and add your aesthetics. They can be whatever colors and shapes you'd like. You can reference real animals for accurate depictions, make up your own markings, or use a bit of both.

Fursonas are very personal characters that represent their owners. Anyone can design their own fursona!

Here are a few of my characters, including my fursona, to show examples of personalized accessories and markings. They all have markings special to their designs that I made for myself!

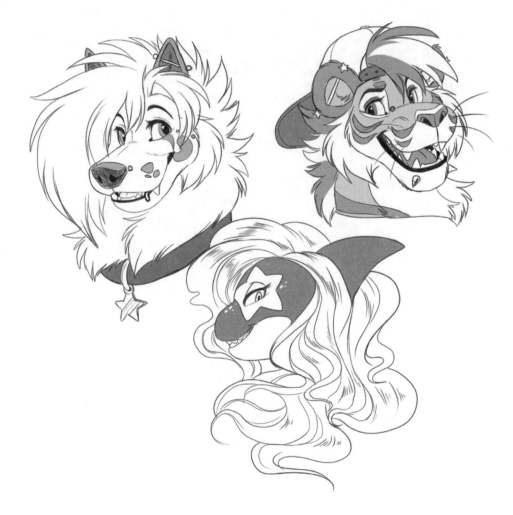

Taur Body

"Taur" is a term used in the fandom to describe characters with an anthro body connected onto a feral body. Think of a centaur or a minotaur; the concepts are the same, except this is the idea of taking a furry character and making them into a taur!

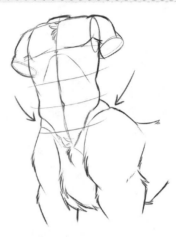

The anthro body stops at the hips and transitions into the feral body's chest area—making the feral front legs the "feet," but also having another section of body with the feral back feet.

The anthro body also stops at the bottom of the spine and the rest of the taur body continues into the neck/shoulder area on the feral body, making two usually separate bodies come together for one creature.

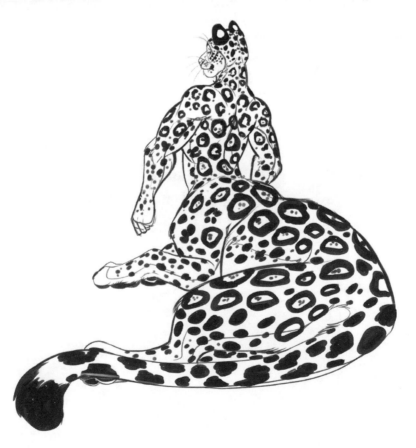

Here is a step by step for drawing a taur full body.

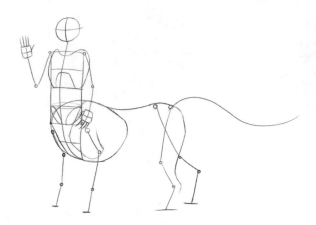

Step 1 Use the skills you have learned from practicing anthro bodies, and from observing references of feral animals, to create structure lines for your taur body. It should look similar to this!

Step 2 Start to block in your basic shapes for both the anthro body and the feral one. Drawing characters like this takes more time, since it is drawing an extra half-body's worth of character! But doing so will help you figure out how to refine things much more easily.

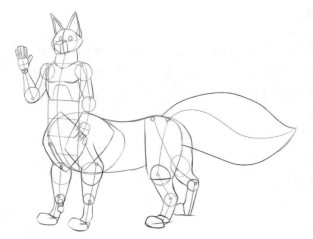

Step 3 Detail your body lines, face, fingers, and toes.

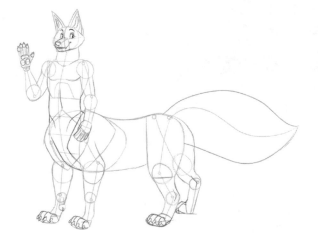

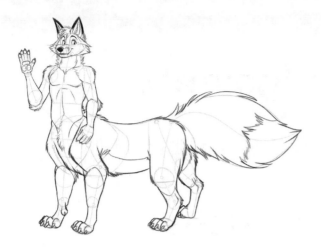

Step 4 Refine the drawing with fur detail and markings—and your taur is complete!

Acknowledgments

Thanks to the Arts Academy in the Woods and the College for Creative Studies for giving me the tools to succeed in my art career. I miss those days, and I will always cherish them.

About the Author

Stephanie is a furry fandom artist working in the fandom for over a decade. She lives in central Illinois with her husband, working on illustration and graphic design projects. She has a bachelor's degree in illustration with a minor in animation from the College for Creative Studies in Detroit, Michigan. Her influences include cartoons from the '80s and '90s, anime, and video games.